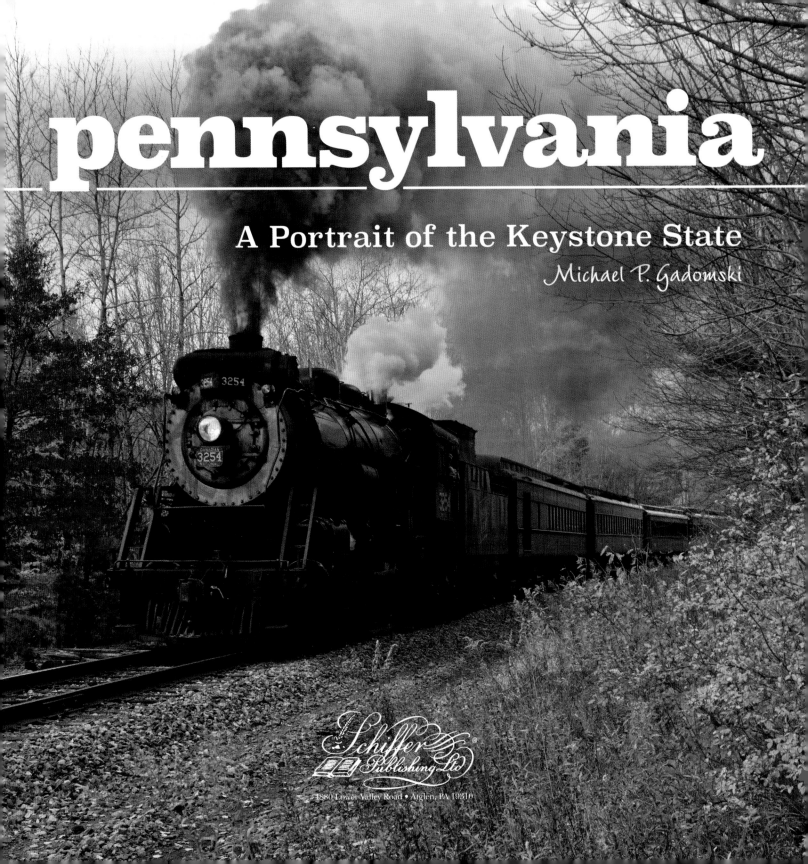

pennsylvania

A Portrait of the Keystone State

Michael P. Gadomski

Schiffer Publishing Ltd

4880 Lower Valley Road • Atglen, PA 19310

Other Schiffer Books by the Author:
Reserves of Strength: Pennsylvania's Natural Landscape
978-0-7643-4422-0

Pittsburgh: A Renaissance City, 978-0-7643-4923-2

The Poconos: Pennsylvania's Mountain Treasure, 978-0-7643-4924-9

Philadelphia: Portrait of a City, 978-0-7643-5108-2

Published by Schiffer Publishing, Ltd.
4880 Lower Valley Road
Atglen, PA 19310
Phone: (610) 593-1777; Fax: (610) 593-2002
E-mail: Info@schifferbooks.com
Web: www.schifferbooks.com

Copyright © 2016 by Michael P. Gadomski

Library of Congress Control Number: 2016930296
Cover design by Danielle Farmer
Type set in Superclarendon
ISBN: 978-0-7643-5107-5
Printed in China

For our complete selection of fine books on this and related subjects, please visit our website at www.schifferbooks.com. You may also write for a free catalog.

Schiffer Publishing's titles are available at special discounts for bulk purchases for sales promotions or premiums. Special editions, including personalized covers, corporate imprints, and excerpts can be created in large quantities for special needs. For more information, contact the publisher.

We are always looking for people to write books on new and related subjects. If you have an idea for a book, please contact us at proposals@schifferbooks.com.

Dedication

To my wife "Smitty" for all her "giggles and hugs" and for patiently proofreading my somewhat dyslexic script.

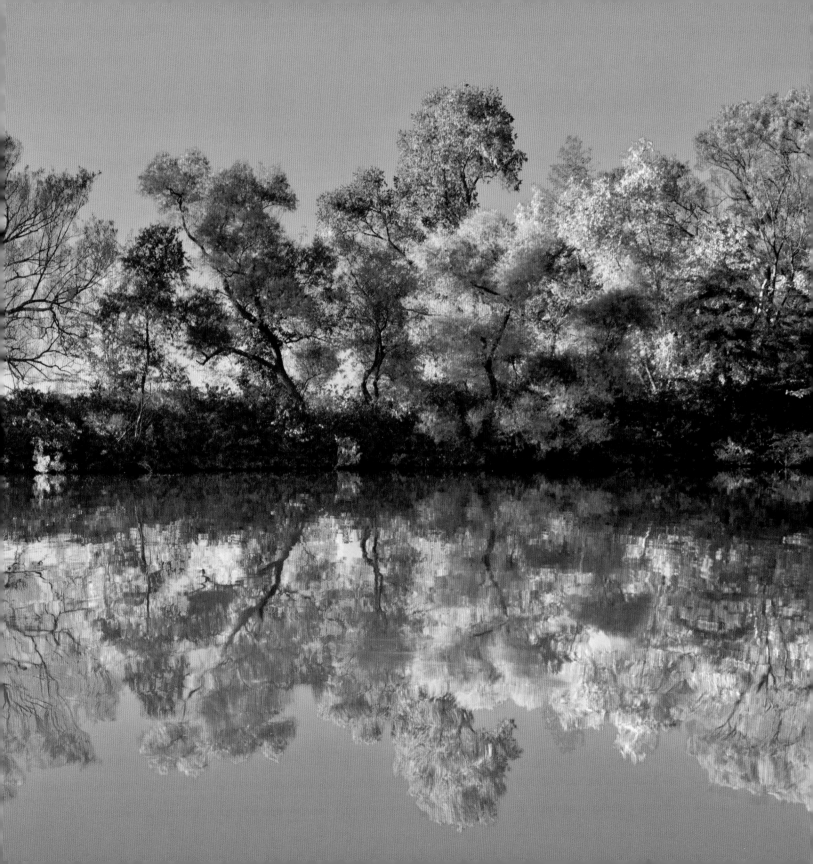

Introduction

The history of humans in Pennsylvania could be one of the oldest in the Western Hemisphere. Artifacts from the Meadowcroft Rockshelter archaeological site in southwestern Pennsylvania's Washington County suggest that the area has been continually inhabited since Paleo-Indian times, 19,000 years ago. Later, during Pre-Columbian times, several Native American tribes inhabited parts of the state, including Lenape, Shawnee, Susquehannock, Iroquois, Erie, Mahican, and Conoy.

The first Europeans settled in the tidewater region of southeastern Pennsylvania. In 1638 the Swedes established the New Sweden Colony on Tinicum Island in the Delaware River. The Dutch followed in 1655, establishing the New Netherland colony, and finally the British arrived in 1681 when William Penn founded the province of Pennsylvania or the Pennsylvania Colony as dictated in a royal charter from King Charles II. This colony included three counties that became semiautonomous in 1704 and were named the State of Delaware in 1787. In the eighteenth century, the French began to expand into western Pennsylvania and in 1754 established Fort Duquesne at what is now Pittsburgh.

The Pennsylvania Colony was named in honor of William Penn's father, Admiral William Penn. The name was combined with the Latin word sylvania, meaning woods or forest: Penn's Woods. Penn established the colony partly for religious freedom—for his fellow Quakers to practice the "Holy Experiment"— and partly as a place to make money by selling shares of land. Philadelphia became the colony's center and was known as The City of Brotherly Love. Soon other religious groups followed, including Huguenots, Puritans, Catholics, Calvinists, Anglicans, and Jews. New immigrants included the Welsh, German, Scots-Irish, and French. The African American population also began to grow while several Native American tribes and the early Swedish and Dutch settlers continued to live in the area.

A colonial government was established in 1683 and consisted of an appointed governor, the proprietor (William Penn), a seventy-two-member provincial council, and a larger general assembly.

The colony expanded quickly, first north along the Delaware River and then west toward the Allegheny frontier. As the British colonies advanced westward, Pennsylvania was at the forefront of the French and Indian War.

Pennsylvania played a major role in the American Revolutionary War, with Philadelphia serving as the center of the federal government almost continuously from 1776 to 1800. The Declaration of Independence, Articles of Confederation, and the United States Constitution were all debated and signed in Pennsylvania. Major battles during the war were also fought here.

During this period, as the new nation was coming into being, Pennsylvania adapted the designation Commonwealth of Pennsylvania instead of State of Pennsylvania. Commonwealth is a traditional English term for a community founded for the "common weal" or common good—welfare for all with supreme power vested in the people. Only three other states claim the designation of "commonwealth."

In 1972, Pennsylvania voters again endorsed this "common good" concept by ratifying a state constitutional amendment. Article I, Section 27, states, "The people have a right to clean air, pure water, and to the preservation of the natural, scenic, historic, and esthetic values of the environment. Pennsylvania's public natural resources are the common property of all the people, including generations yet to come. As trustee of these resources, the Commonwealth shall conserve and maintain them for the benefit of all the people."

Although it is sometimes called the Quaker State, referring to William Penn's religion and the Quakers who settled here, Pennsylvania's official nickname is the Keystone State. As with most states, there is more than one theory how the nickname came about, but it is generally accepted that the name refers to the central stone in a stone arch, called the keystone, which holds the other stones together. Pennsylvania was in the center of the original thirteen colonies with six to the north and six to the south. In addition to acting as a link between the colonies, Pennsylvania was also central to much of the new country's economic, social, and political development. The nickname was first used around 1800, and it is reported that during the presidential victory rally for Thomas Jefferson in 1802, Pennsylvania was toasted as "the keystone of the federal union."

Today Pennsylvania encompasses 46,055 square miles, and although its size ranks only thirty-third among the fifty states, it is sixth in population, estimated at 12,787,209 in 2014.

Rooted in its founding ethic, Pennsylvania has always welcomed immigrants seeking a better life. Some of the larger ancestry groups that settled in the commonwealth include German, Irish, Italian, African American, English, Polish, French Canadian, Puerto Rican, Dutch, Slovak, Scotch Irish, Scottish, Russian, Welsh, Hungarian, Ukrainian, and Mexican.

One ancestry group is called the Pennsylvania Dutch, though they are actually of German descent. In their German language they called themselves "Deutsch" or "Deitsch," which has been simplified in English to "Dutch." This notable group is made up of the Amish,

Mennonites, Moravians, and several other related Protestant denominations.

Penn set a precedent for religious diversity. Almost every rural village has at least one church. Olyphant, a small borough of less than 5,200 people, in Lackawanna County, has eight churches of different denominations including Saints Cyril and the Methodius Ukrainian Greek Catholic Church, one of the oldest Ukrainian Catholic Churches in the Western Hemisphere and established in 1888. This former coal-mining town is part of the Lackawanna Heritage Valley National and State Heritage Area, the first of its kind in Pennsylvania. In 2000, the US Congress recognized the region for its unique contribution to the American experience. Eight other National Heritage Areas have since been designated in Pennsylvania.

Pennsylvania also has plenty of nature biodiversity, partly due to its temperate climate and six major physiographic provinces: the Atlantic Coastal Plain Province, the Piedmont Province, the New England Province, the Ridge and Valley Province, the Appalachian Plateau Province, and the Central Lowlands Province. This has resulted in fertile farmland, vast forests of different types, water resources, and mineral resources including coal, petroleum, and natural gas. Renewable energy, such as wind and solar, has been expanding in the commonwealth in recent years.

The state has approximately 134 native tree species, 418 bird species, 100 fish species, 75 mammal species, and numerous other plants and animals.

At one point in its history, Pennsylvania was called the Breadbasket of America. Today, according to the US Census, Pennsylvania has roughly 63,000 farms totaling nearly 8 million acres. Most are family farms averaging 123 acres.

Like many other northeastern states, Pennsylvania's forests were nearly all clear-cut during the nineteenth-century logging boom. Today, much of its forests have recovered, with fifty-nine percent of the total land area forested. Seventy-one percent of these forested lands are privately owned by individuals, families, and partnerships not engaged in timber harvesting. At the same time, according to the Pennsylvania Forest Products Association, Pennsylvania is the largest producer of hardwood lumber in the United States, with total revenues exceeding $5.5 billion annually and employing 90,000 people.

Major industries in Pennsylvania today include advanced manufacturing, agriculture and food production, biomedical, construction, business services, education, energy, health care, leisure and entertainment, transportation, and real estate and finance. Gone are the days when mining and steel making, with their smog and pollution, typified the state. Although these industries are still present, environmental regulations have made them much cleaner.

Things have changed a lot since William Penn set up his tiny colony in the woods on the banks of the Delaware River less than 350 years ago. But one thing will not change: Pennsylvania will continue adapting to the times while remaining an example and a keystone for the rest of the nation.

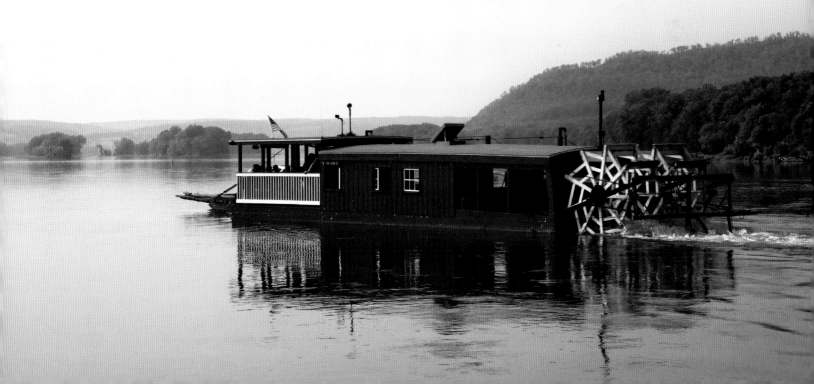

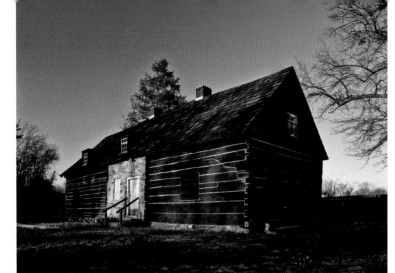

The log cabin on the Morton Homestead in Delaware County is one of the oldest houses in Pennsylvania. The homestead dates to 1654 when Pennsylvania was known as New Sweden.

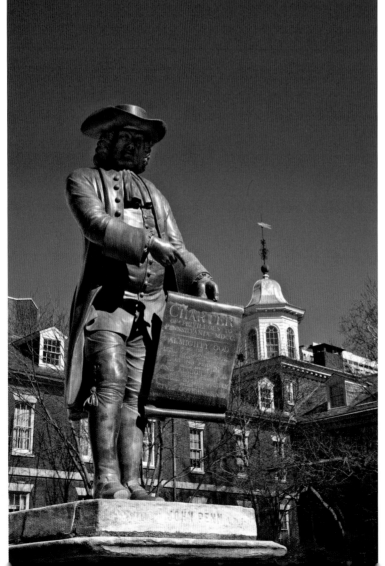

William Penn statue outside the Pennsylvania Hospital in Philadelphia displays a copy of Article One of the Charter of Privileges, which served as the constitution of the Pennsylvania Colony until the American Revolution.

Pennsbury Manor in Bucks County is the re-created colonial estate of William Penn, founder of the Pennsylvania Colony. Penn lived here from 1683 to 1701 when not in Philadelphia.

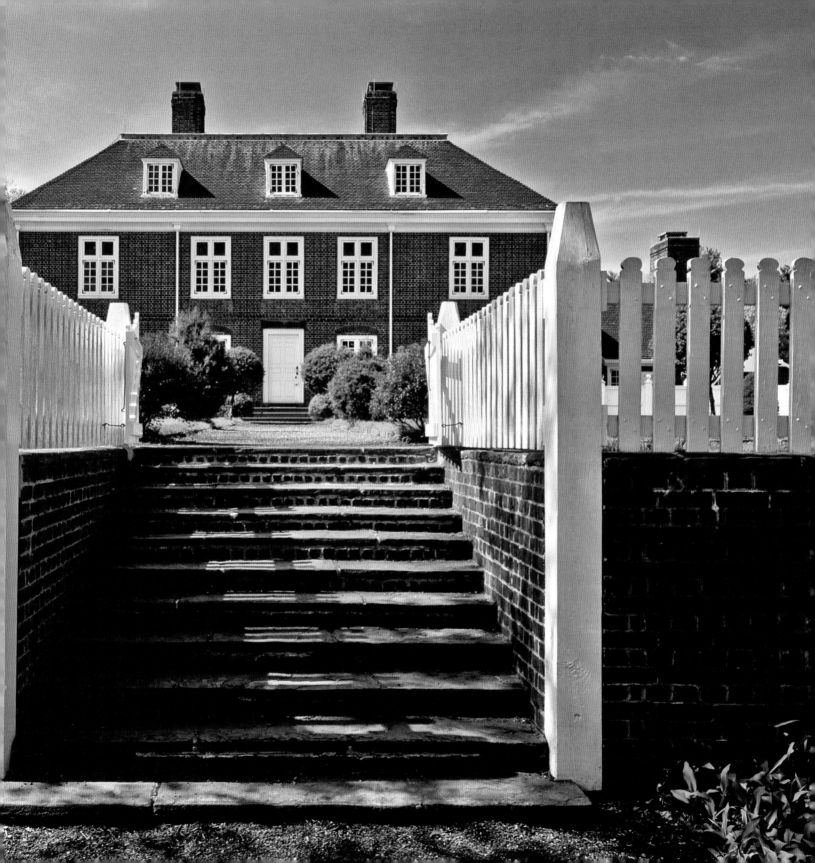

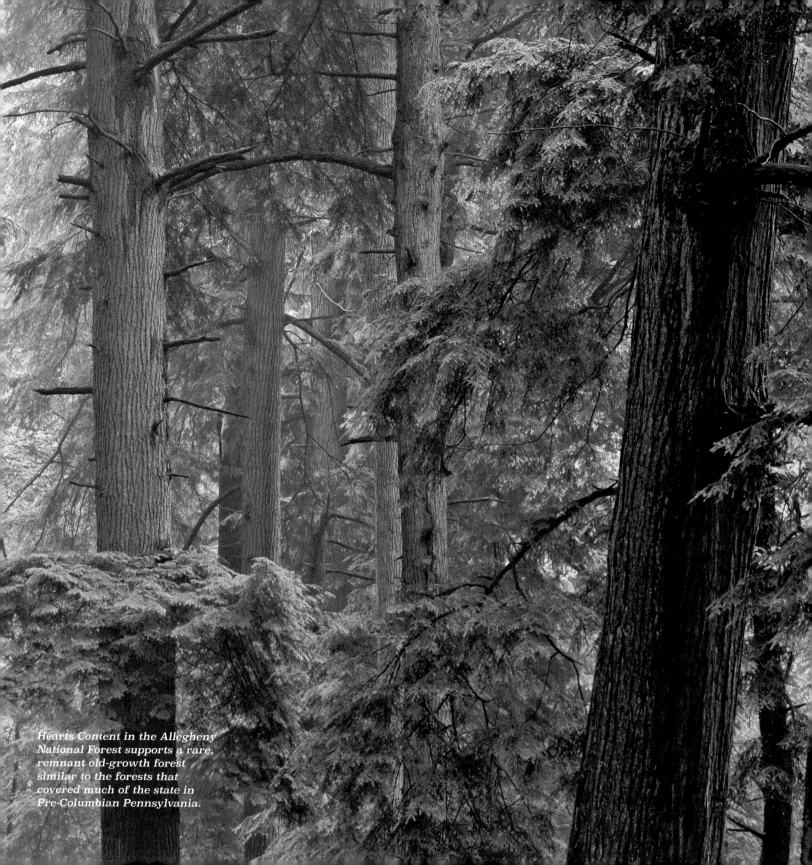

*Hearts Content in the Allegheny
National Forest supports a rare,
remnant old-growth forest
similar to the forests that
covered much of the state in
Pre-Columbian Pennsylvania.*

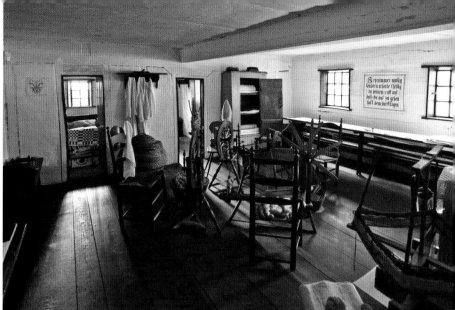

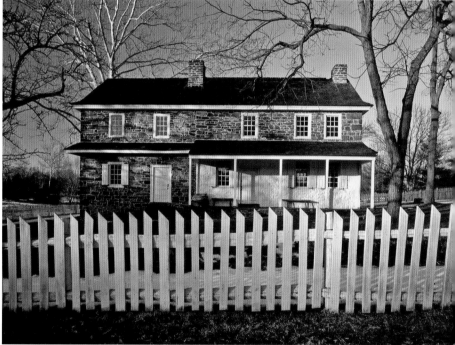

The Weaver's House is one of several buildings preserved and administered by the Pennsylvania Historical and Museum Commission at Ephrata Cloister in Lancaster County. The Ephrata Cloister was a farming and industrial-centered religious community, of German origin, established in 1732. Many of its members practiced celibacy.

The Daniel Boone Homestead in Birdsboro, Montgomery County, preserves the birthplace of the legendary American frontiersman. He lived here from his birth in 1734 until 1750 when his family moved to North Carolina.

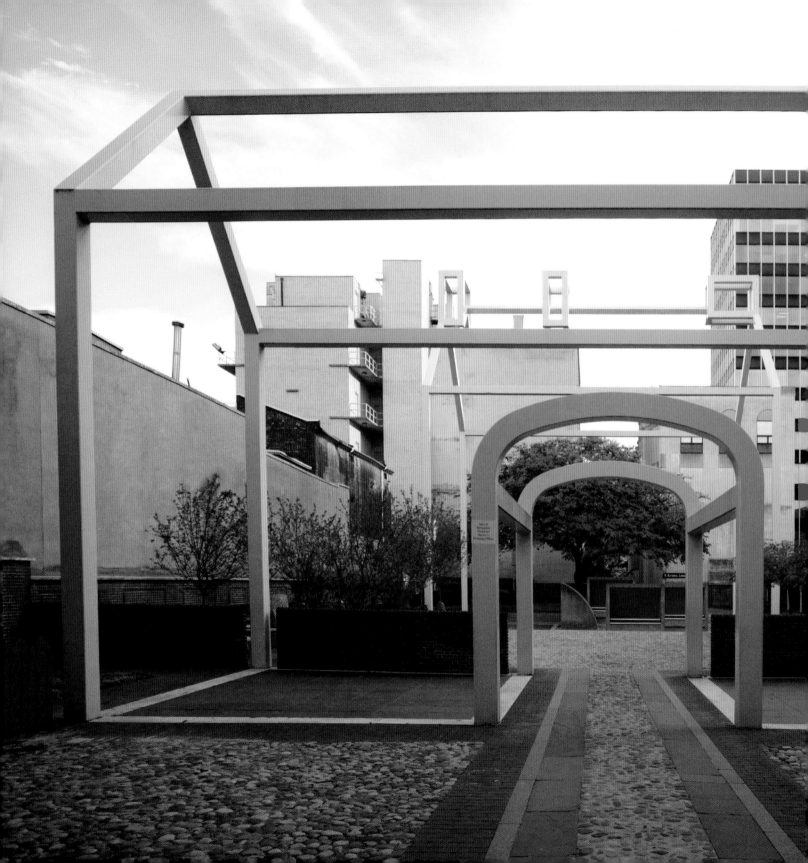

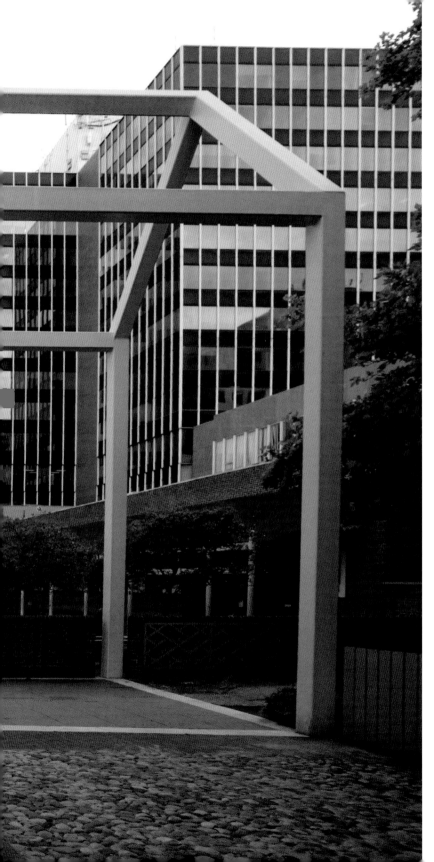

Benjamin Franklin's original house and print shop were torn down about twenty years after his death in 1790, but the "ghost" outline is preserved at Franklin Court, part of Independence National Historic Park, along Market Street in Philadelphia.

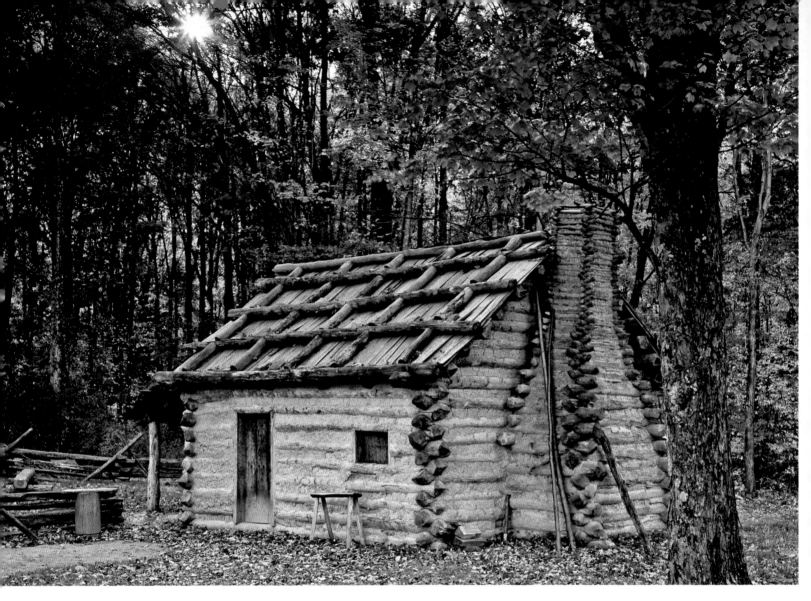

A re-created log cabin, typical of the
temporary dwellings built by American and
European settlers around 1770, can be seen
at the Somerset Historical Center in
Somerset County.

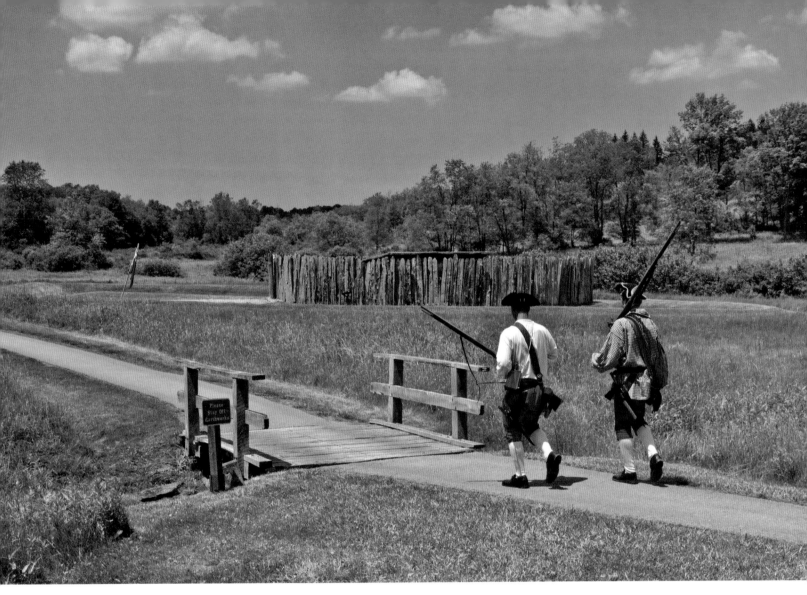

Fort Necessity National Battlefield in Fayette County preserves the site of the July 3, 1754, Battle of Fort Necessity, an early battle in the French and Indian War, where British colonial forces under General George Washington were forced to surrender to the French and Indians.

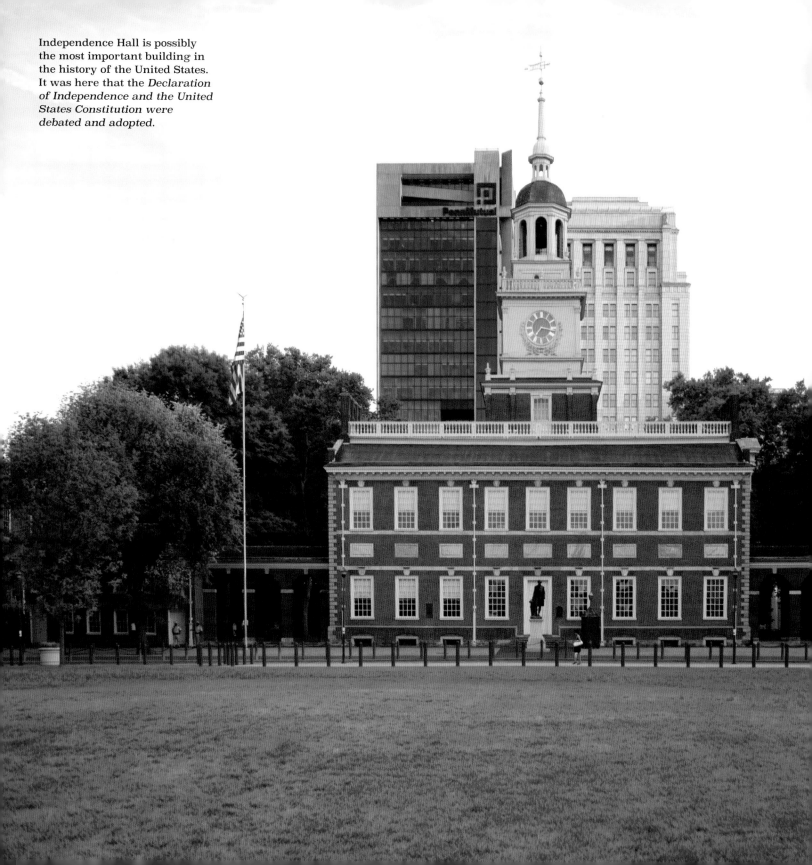

Independence Hall is possibly the most important building in the history of the United States. It was here that the *Declaration of Independence and the United States Constitution were* debated and adopted.

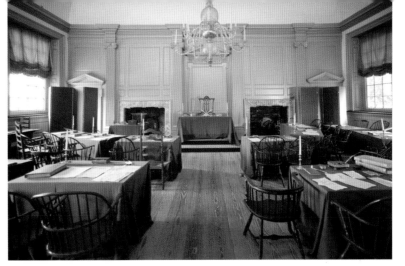

The Declaration of Independence and the United States Constitution were signed in the Assembly Room in Independence Hall, Philadelphia. Years later, President Lincoln's body lay in repose here for two days following his assassination.

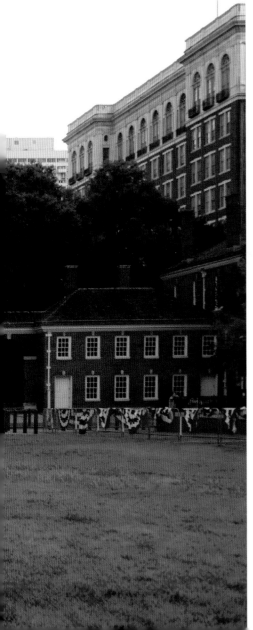

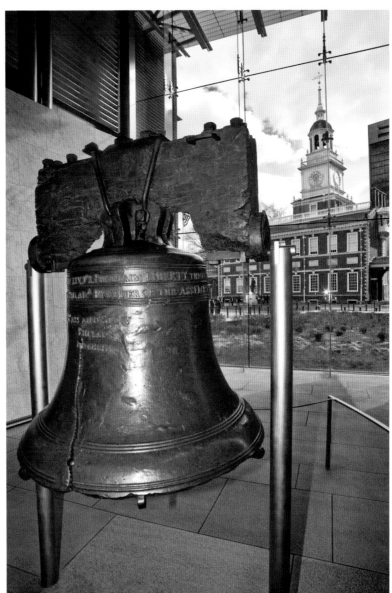

The Liberty Bell and Independence Hall, preserved at Independence National Historical Park in Philadelphia, are two of the most recognizable symbols in US history.

15

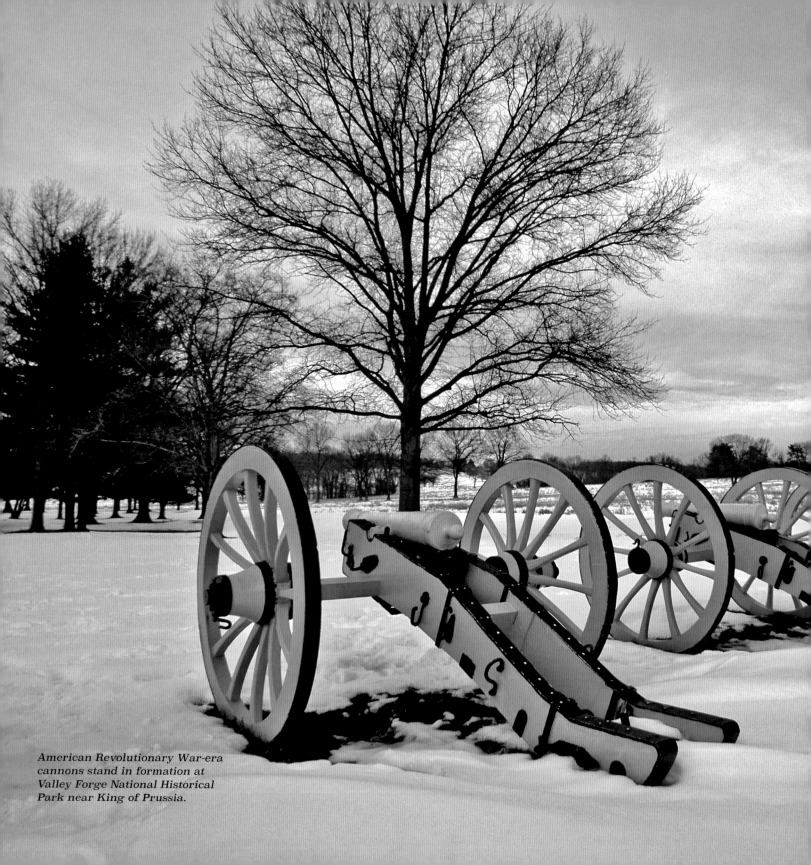

American Revolutionary War-era cannons stand in formation at Valley Forge National Historical Park near King of Prussia.

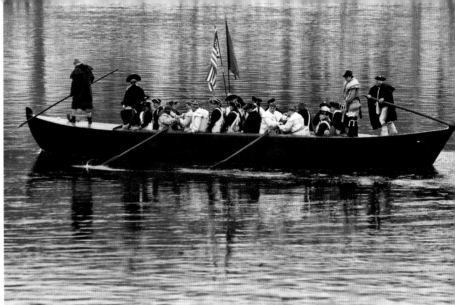

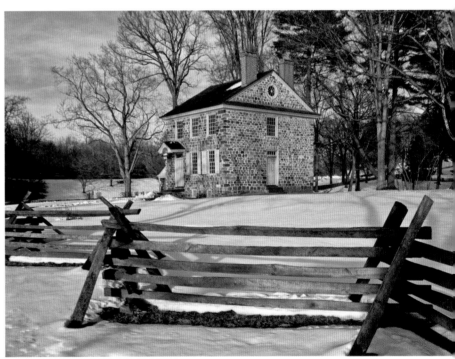

Every year on Christmas Day, a reenactment of General George Washington's historic crossing of the Delaware River occurs at Washington Crossing Historic Park in Bucks County. River conditions permitting, a full dress rehearsal is performed on a weekend about two weeks before Christmas.

General George Washington used the Isaac Potts House as his headquarters during the Continental Army's encampment at Valley Forge, 1777–78. The house is open to the public at Valley Forge National Historical Park.

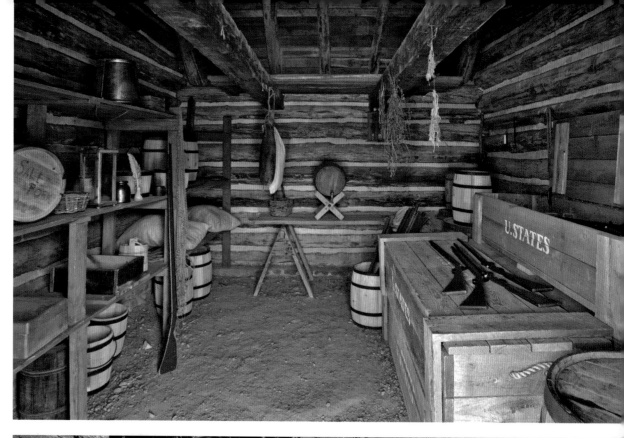

Originally constructed in 1778, Fort Roberdeau in Blair County was reconstructed as a Bicentennial project in 1975–76. The storehouse shown here stockpiled food and military supplies for troops housed at the fort.

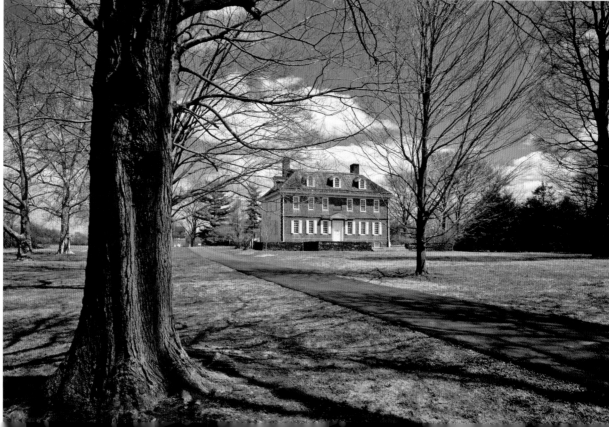

Hope Lodge, a Georgian country mansion, was used as a hospital for George Washington's troops during their encampment at nearby Fort Washington, Montgomery County. It was built between 1743 and 1748.

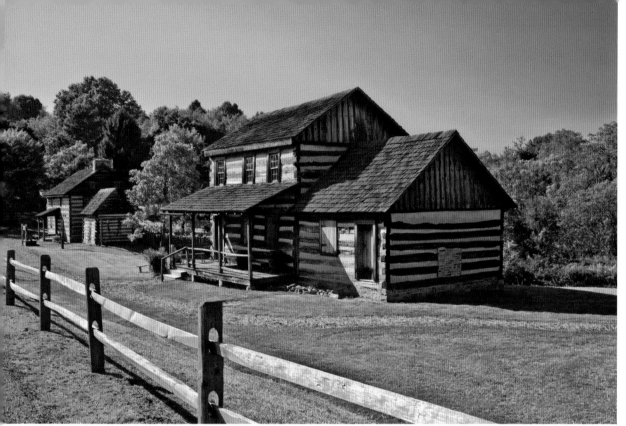

Historic Hanna's Town is the restored and rebuilt late eighteenth-century village that served as the first Seat of Westmoreland County and first English court west of the Allegheny Mountains. The site is maintained through a partnership between the Westmoreland County Historical Society and Westmoreland County Parks and Recreation.

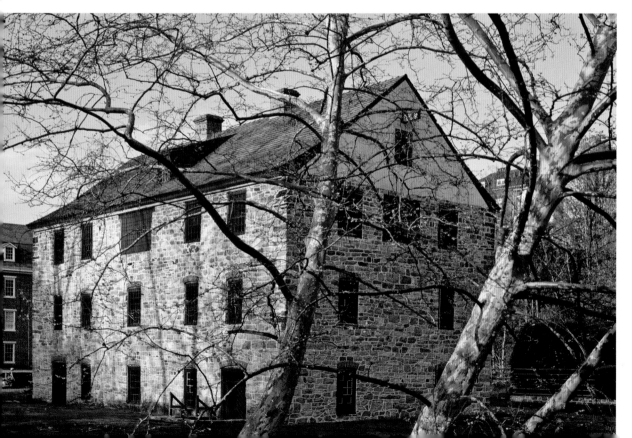

The Tannery, in the historic Bethlehem Colonial Industrial Quarter, was built in 1761 and added to the National Register of Historic Places in 1972.

Constructed in 1722, Graeme Park in Montgomery County is the only surviving residence of colonial-era Lieutenant Governor Sir William Keith. The Pennsylvania Historical and Museum Commission maintains this site.

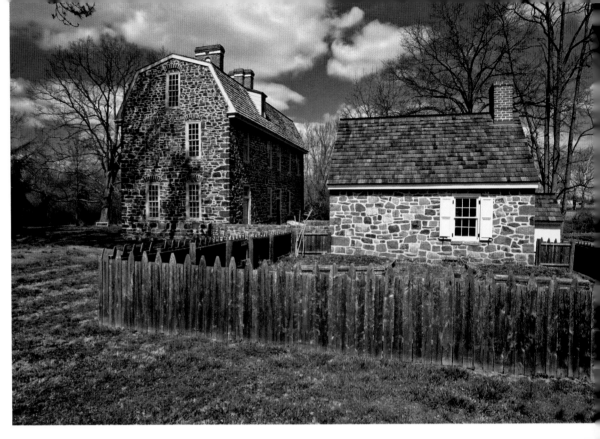

Administered by the National Park Service, Hopewell Furnace National Historic Site in Berks County exemplifies American nineteenth-century rural iron making and everyday life.

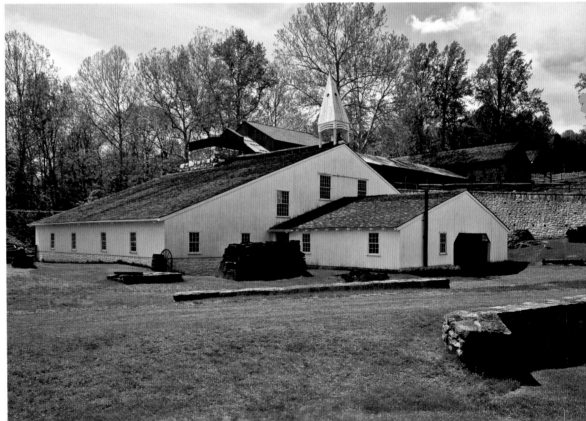

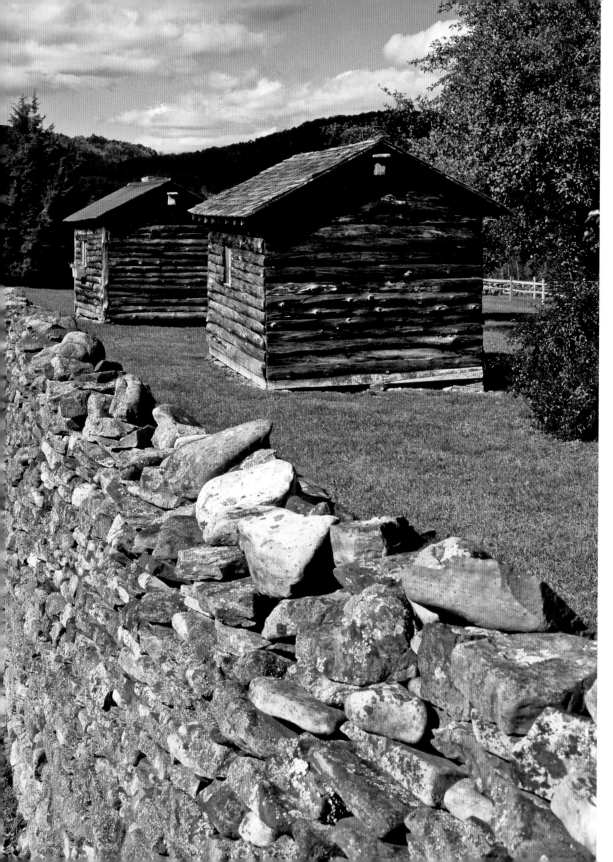

For ten years, French Azilum was a refuge for loyalists of French King Louis XVI during the French Revolution. Recreated log cabins from the 1780s sit on a horseshoe bend along the North Branch Susquehanna River in Bradford County.

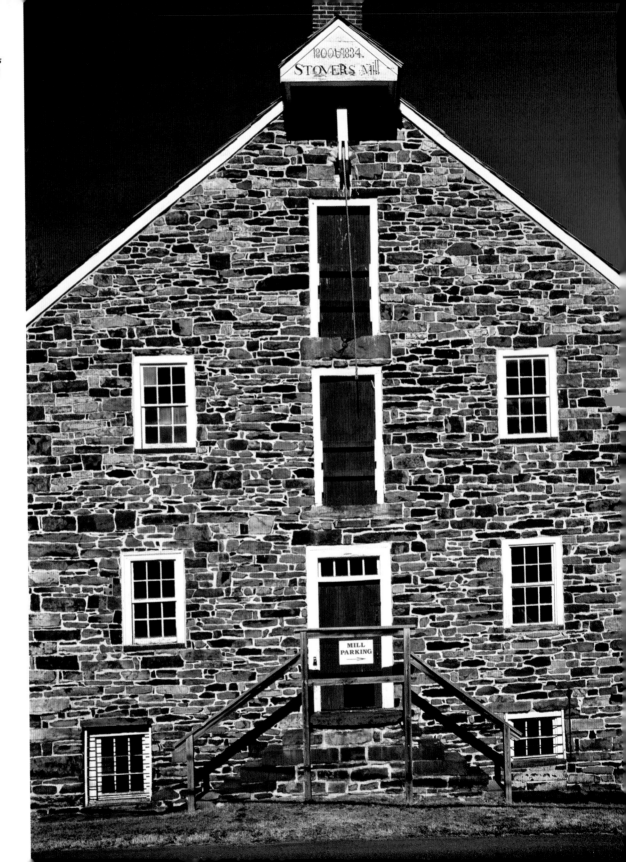

Stover Mill, a Bucks County grist mill built in 1832, serves as an art gallery and is listed on the National Register of Historic Places.

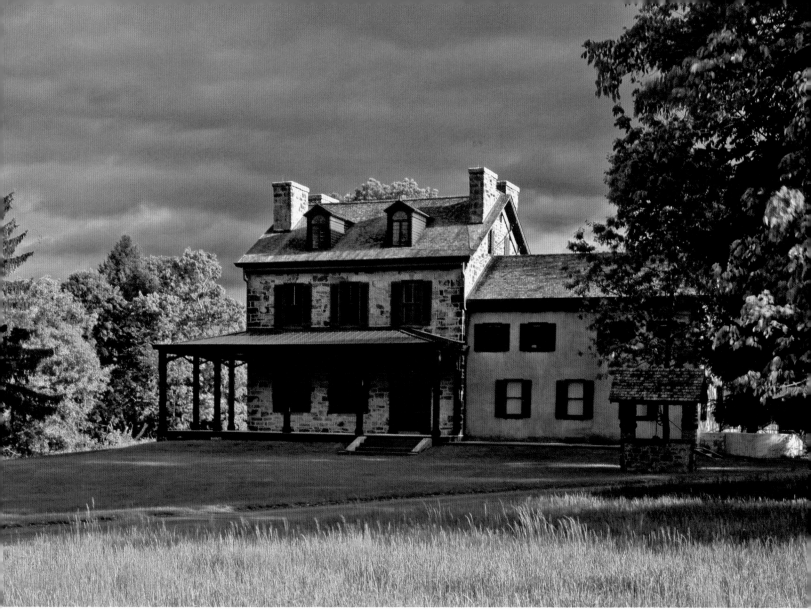

Friendship Hill National Historic site in Fayette County was the home of Albert Gallatin, who served as secretary of the Treasury under Presidents Thomas Jefferson and James Madison, in addition to serving as a US congressman, senator, and US minister to France and the United Kingdom.

The Pennsylvania Capitol in Harrisburg was dedicated on October 4, 1906. In his dedication speech, President Theodore Roosevelt said, "This is the handsomest building I ever saw." Philadelphia architect Joseph Huston designed it in the American Renaissance style.

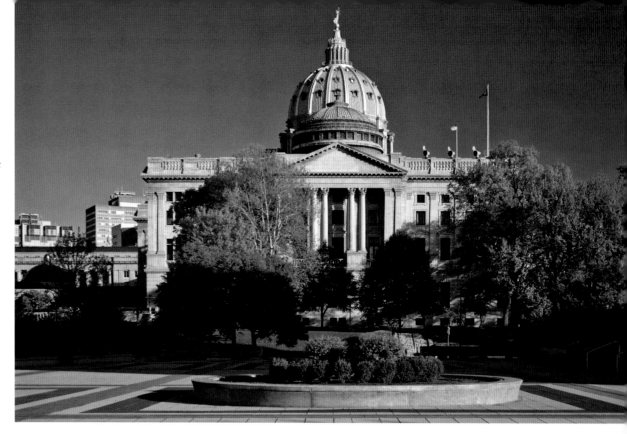

The Pennsylvania Capitol building is frequently called a palace of art. Its dome interior displays four lunette murals symbolizing Pennsylvania's spiritual and industrial contribution to civilization. Four medallions represent the four forces of civilization: art, science, religion, and justice. They were painted by Edwin Austin Abbey.

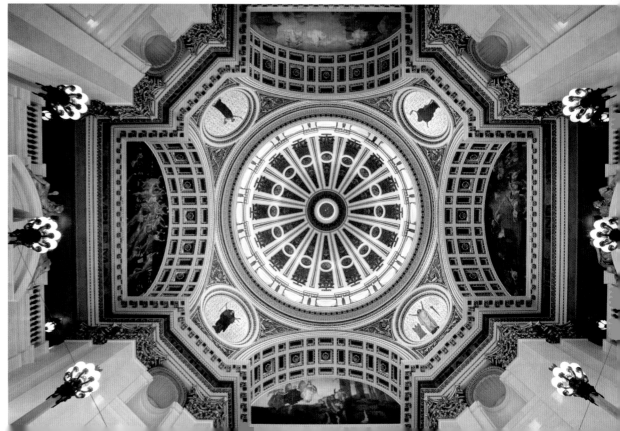

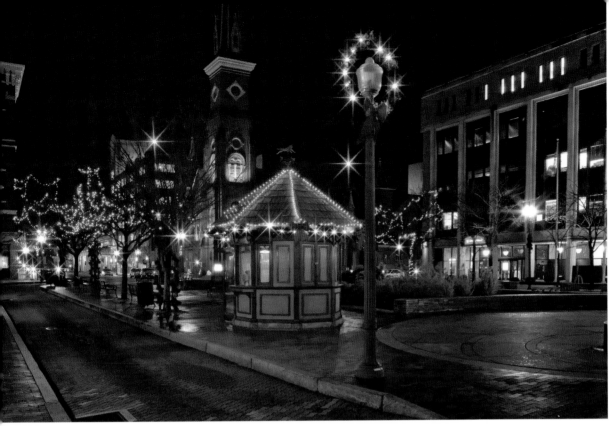

Seasonal decorations at Market Square lend holiday merriment to downtown Harrisburg.

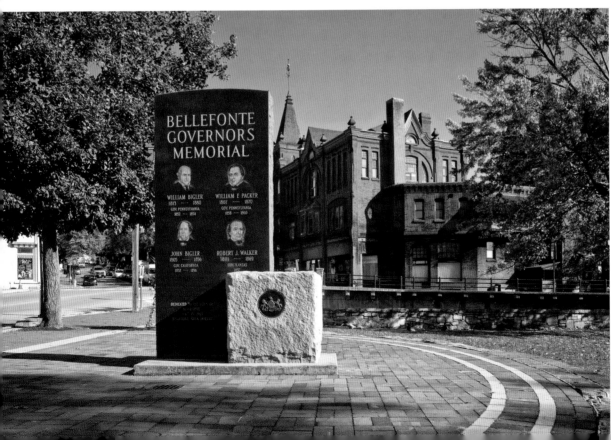

The Bellefonte Governors Memorial honors the seven governors who lived, worked, or studied in the borough of Bellefonte in Center County.

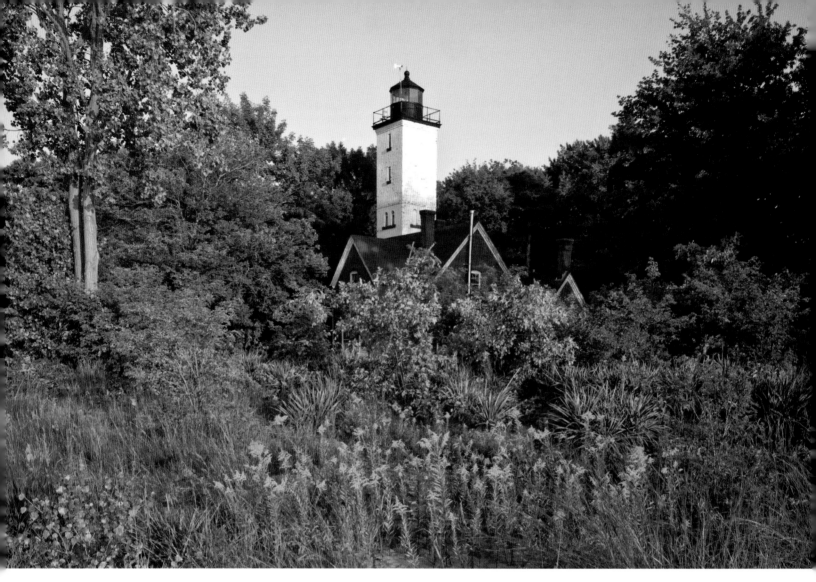

The fifty-seven-foot Presque Isle Lighthouse, built in 1872, is a landmark along the Lake Erie shoreline at Presque Isle State Park in Erie County.

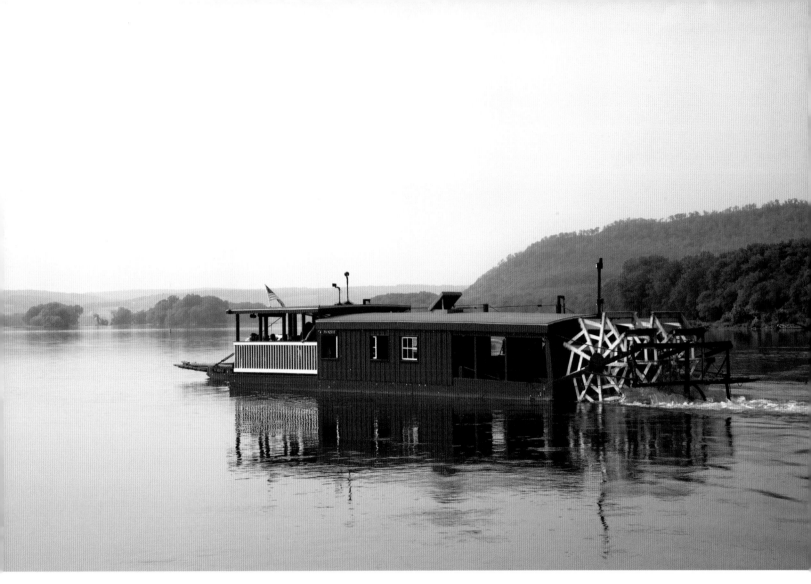

Established in the early nineteenth-century, the Millersburg Ferry is the last operating ferry on the Susquehanna River and is believed to be the last wooden double stern-wheel paddle boat operating in the United States. It transports passengers and vehicles between Dauphin and Perry Counties.

27

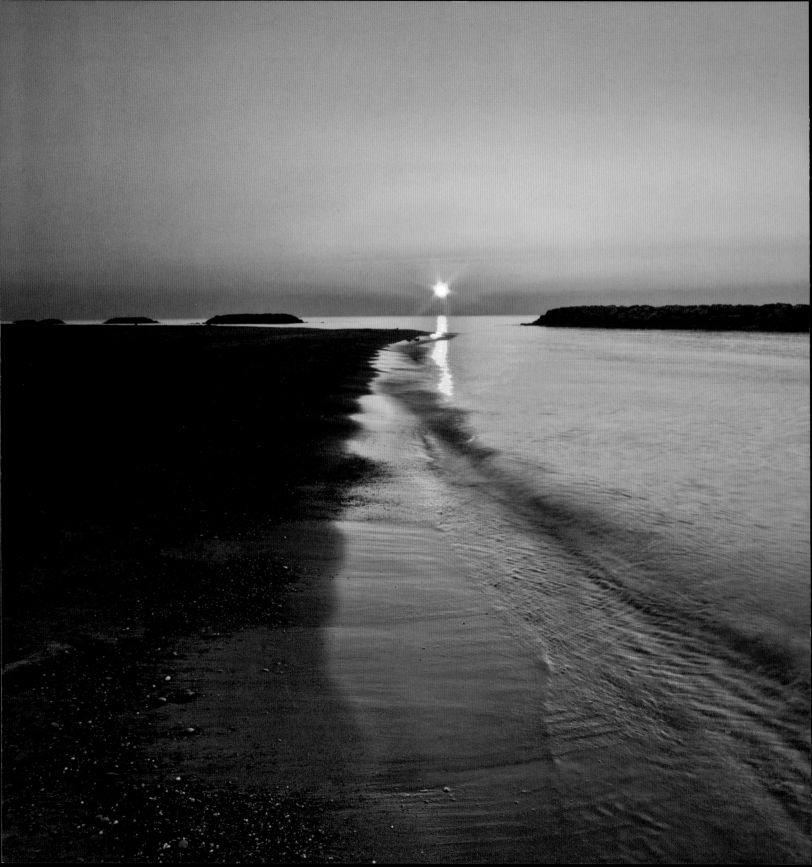

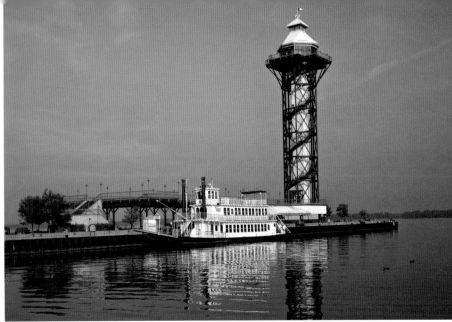

The Bicentennial Tower in Erie was built in 1996 in honor of the city's bicentennial. Towering 187 feet, it offers panoramic views of the city and Lake Erie.

Some say that the seven-mile-long beach at Presque Isle State Park, on Lake Erie, has the best sunsets in the state.

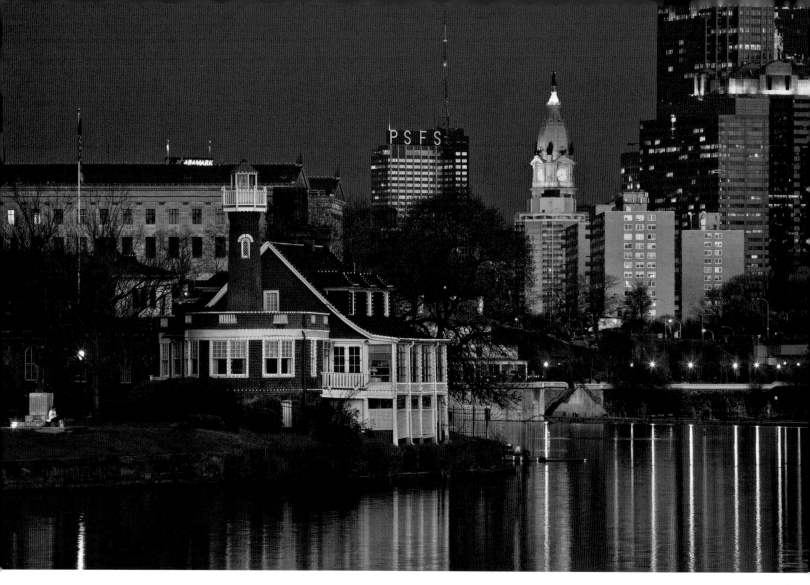

*Turtle Rock Lighthouse, built in 1887, and
the Philadelphia skyline reflect in the
Schuylkill River near Boathouse Row.*

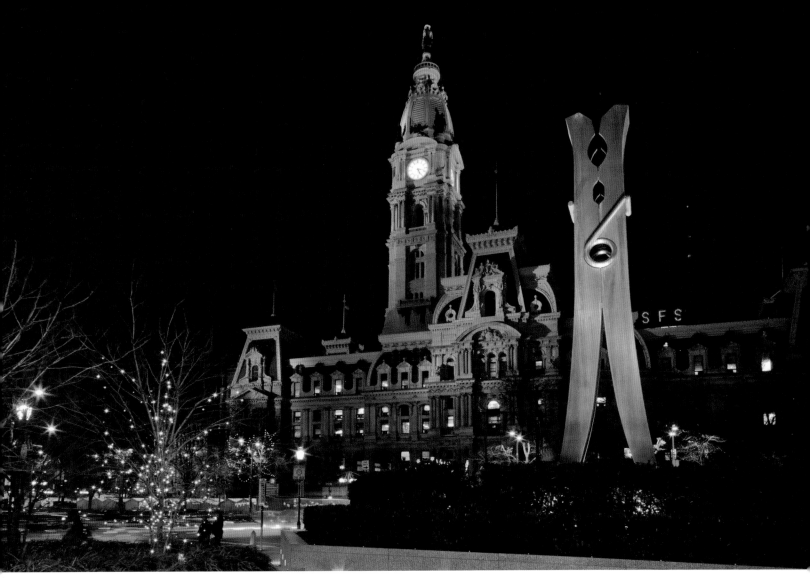

The ornate, late-nineteenth-century city hall and forty-five-foot Claes Oldenburg Clothespin are two unmistakable landmarks in Center City Philadelphia.

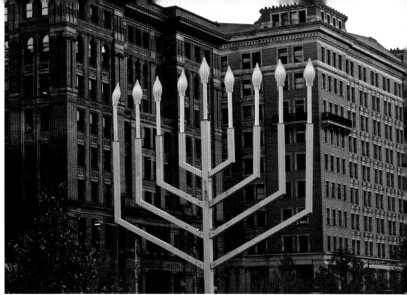

A giant menorah lights the Judge Lewis Quadrangle across from Independence Hall in Philadelphia, celebrating Hanukkah, the eight-day Jewish Festival of Lights.

Society Hill, in Philadelphia's Center City neighborhood, is said to have the largest concentration of original eighteenth- and early nineteenth-century residential architecture in the United States. Federal and Georgian brick row houses line cobblestone streets.

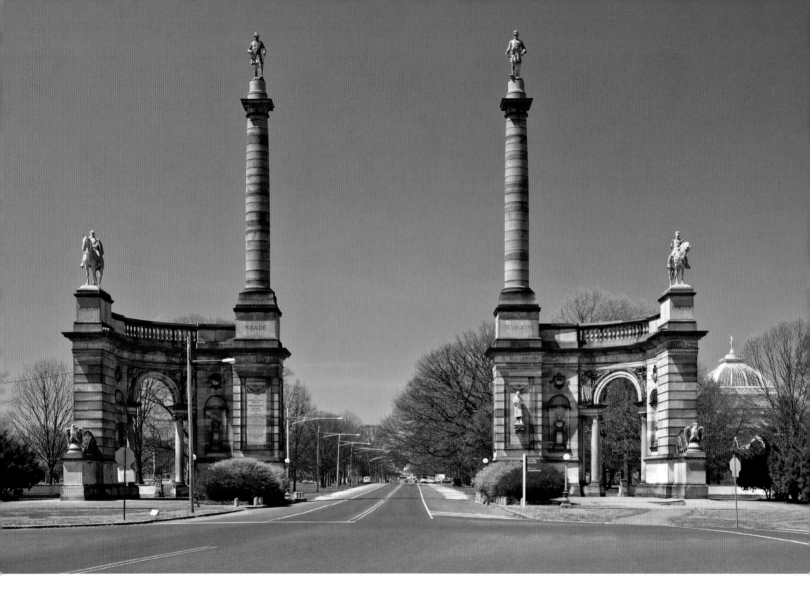

Smith Memorial Arch is a Civil War monument on the grounds of the 1876 Centennial Exposition. Consisting of two massive columns supported by neo-baroque arches and decorated with thirteen portrait sculptures, it serves as an entrance to West Fairmount Park in Philadelphia.

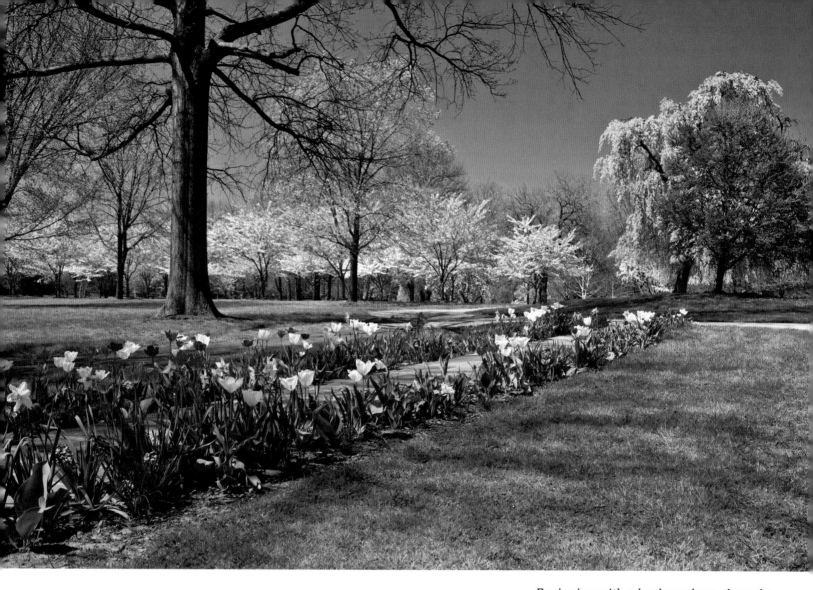

Beginning with a land purchase along the Schuylkill River in 1844 by the city of Philadelphia, the Fairmount Park system has now grown to 9,200 acres consisting of sixty-three neighborhood and regional parks. It is one of the largest urban park systems in the United States.

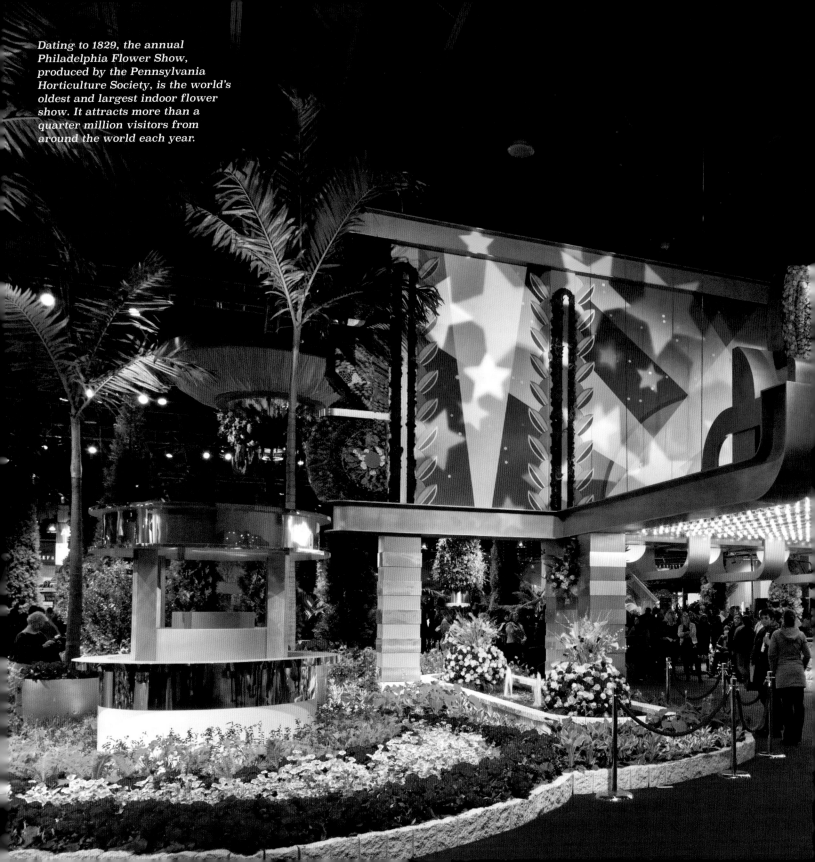

Dating to 1829, the annual Philadelphia Flower Show, produced by the Pennsylvania Horticulture Society, is the world's oldest and largest indoor flower show. It attracts more than a quarter million visitors from around the world each year.

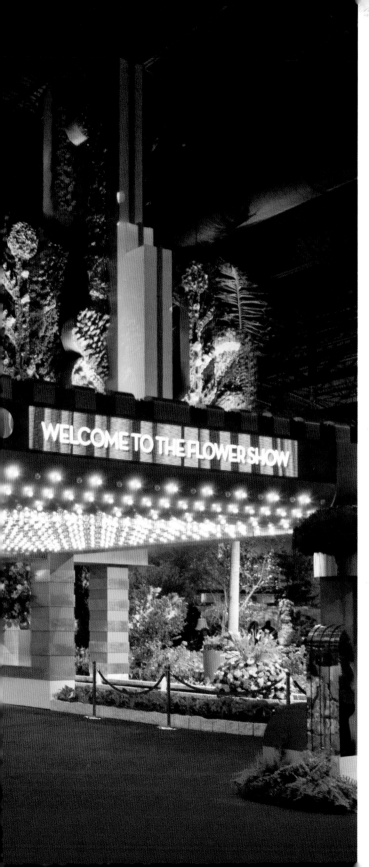

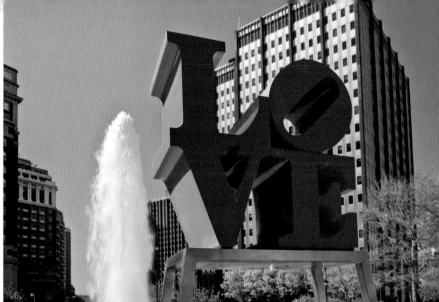

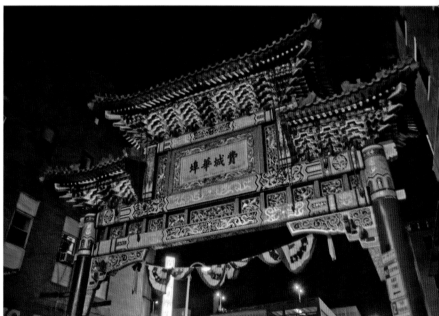

Every tourist to Philadelphia seems to want to be photographed next to Robert Indiana's iconic LOVE statue in JFK Plaza in Center City. The statue was installed during the United States Bicentennial in 1976.

The Chinatown Friendship Arch in Philadelphia was erected in 1984 as a sign of friendship between Philadelphia and Tianjin, China. Also known as the Chinatown Gate, it is the first Chinese gate built in America by artisans from China.

The locktender's house stands along the historic sixty-mile-long canal at Delaware Canal State Park near Raubsville in Northampton County.

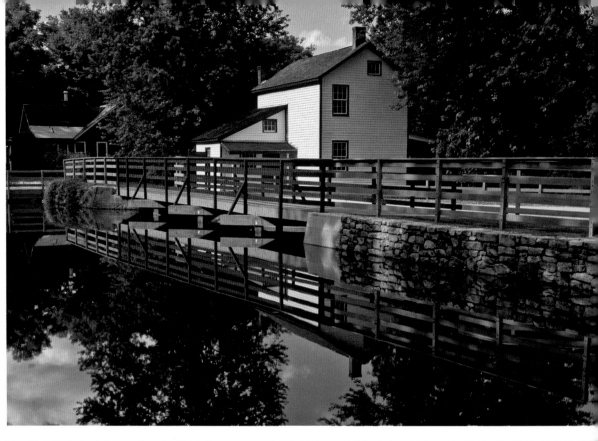

Buchanan's Birthplace State Park in Franklin County honors the only United States president from Pennsylvania, James Buchanan, who served as the fifteenth president from 1857 to 1861.

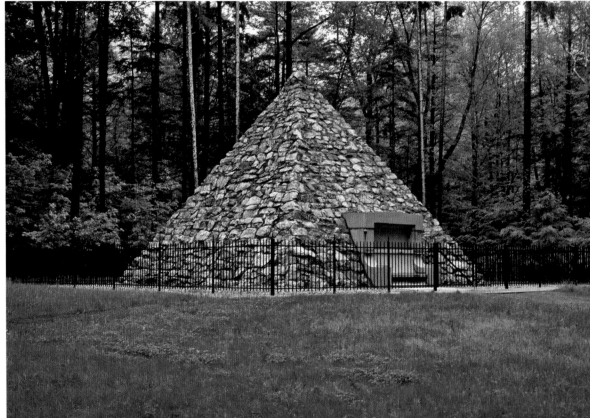

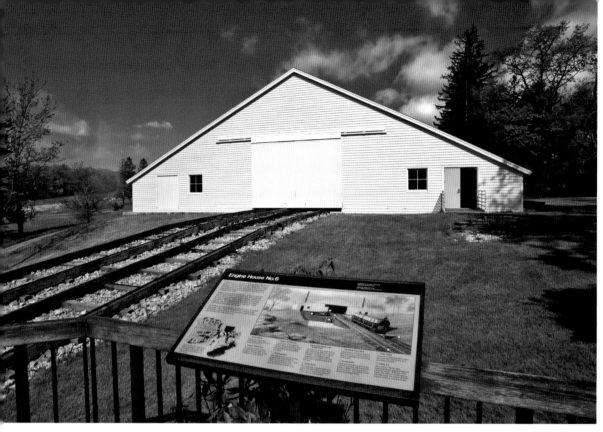

The Allegheny Portage Railroad National Historic Site in Blair and Cambria Counties preserves the remains and interprets this once important link between two canal divisions that operated from 1834 to 1854. The railroad used stationary steam engines to haul canal boats up and over the steep Allegheny Front.

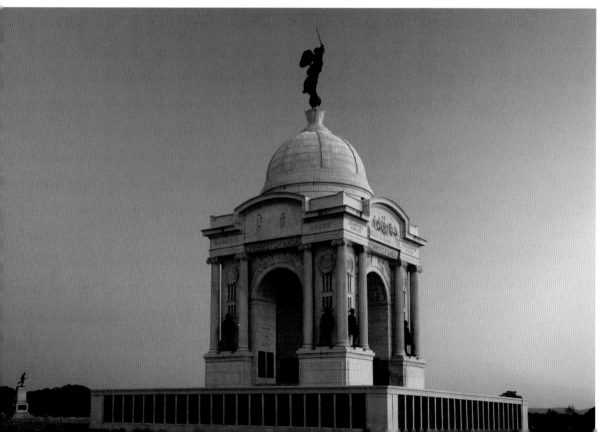

The State of Pennsylvania Monument is the largest of over 1,200 monuments at Gettysburg National Military Park. Dedicated on September 27, 1910, it honors the 34,000 Pennsylvanians who participated in the battle.

39

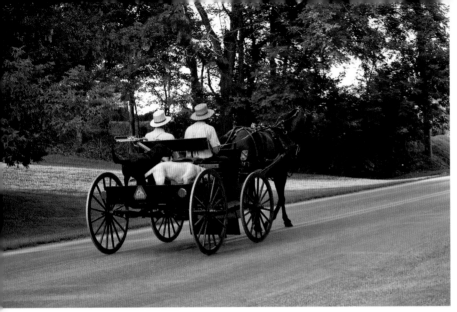

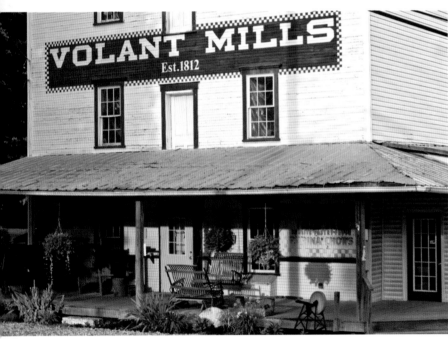

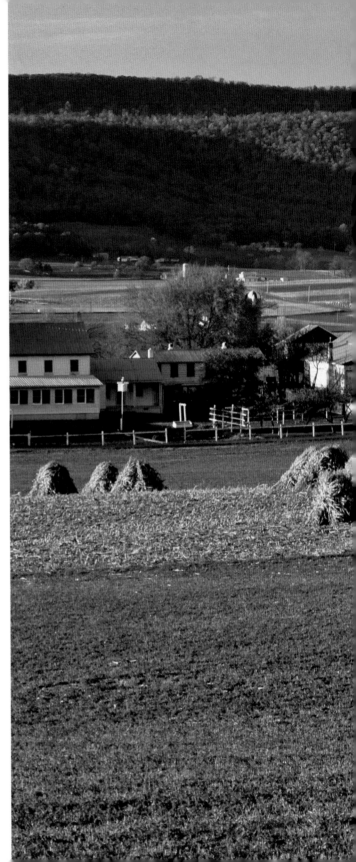

Amish buggies are a common sight along rural roads and in small towns throughout Pennsylvania's Amish communities. Although the Amish allow members to ride in automobiles, they are forbidden to own one, believing it would lead to a breakdown in community unity and cultural purity.

Once an important commercial center in Lawrence County's Amish country, Volant Mills was saved from disrepair in 1984. Today it is owned by the Volant Community Development Corp., a local nonprofit organization, and used as a country mercantile shop and museum interpreting nineteenth-century rural life.

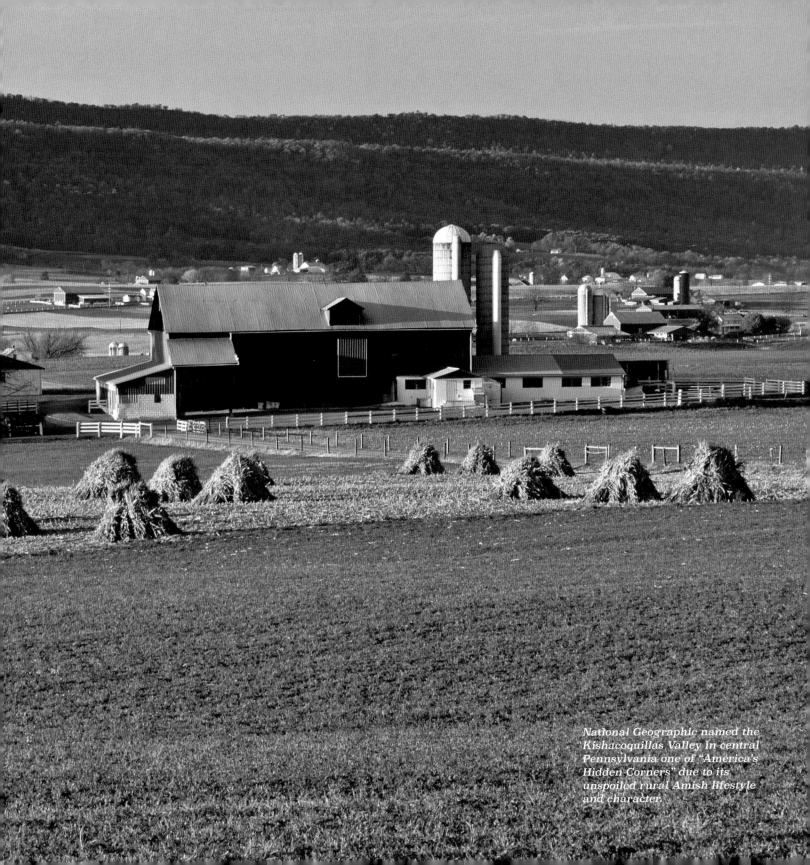

National Geographic named the Kishacoquillas Valley in central Pennsylvania one of "America's Hidden Corners" due to its unspoiled rural Amish lifestyle and character.

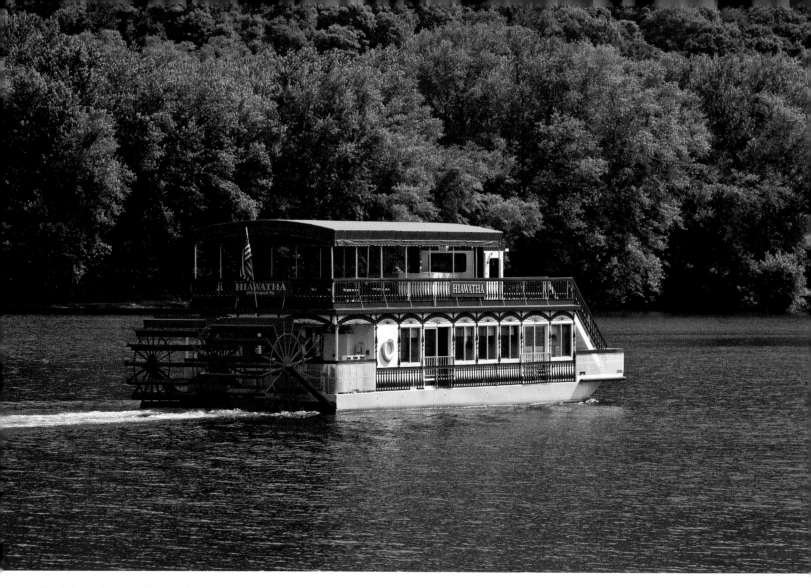

The Hiawatha Paddlewheel Riverboat
offers excursion cruises from May through
October on the Susquehanna River at
Williamsport.

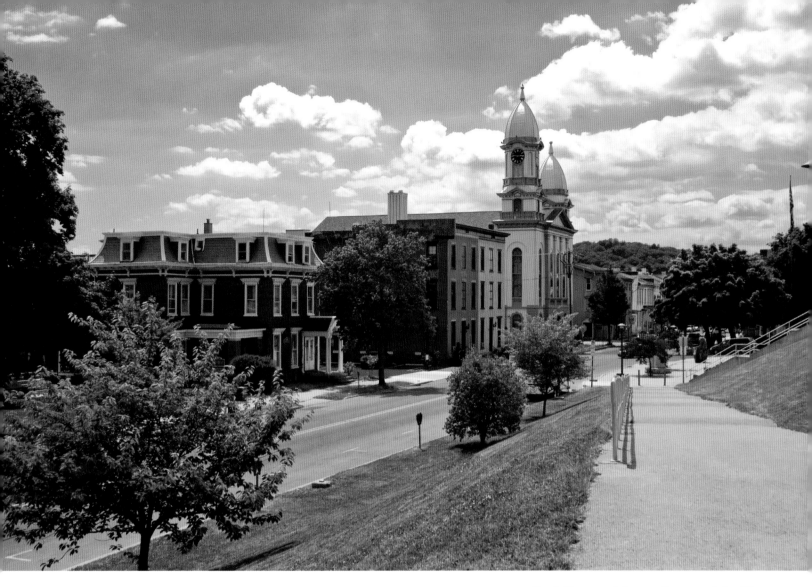

Lock Haven, at the confluence of the West Branch Susquehanna River and Bald Eagle Creek, is the Clinton County seat. Artifacts found in the area suggest that human habitation goes back to 12,000 BCE. During the nineteenth century, the city was a prosperous lumber center.

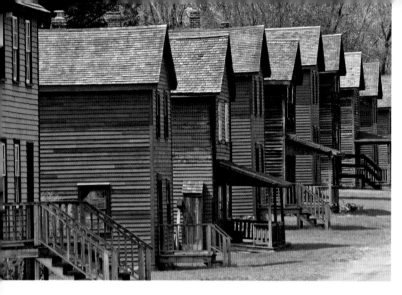

The preserved Eckley Miners' Village in Luzerne County was a nineteenth-century coal company-owned town called a "patch town." Scattered throughout Pennsylvania's coal region, they provided housing, medical care, stores, schools, and churches for the mostly immigrant mining families. Eckley was the setting for the 1970 movie The Molly Maguires.

The borough of Emporium in Cameron County was settled in the early nineteenth century where streams from four different directions joined the West Branch Susquehanna River. Native Americans used them as pathways, making this a place of commerce.

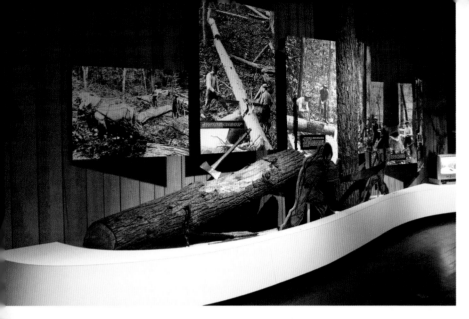

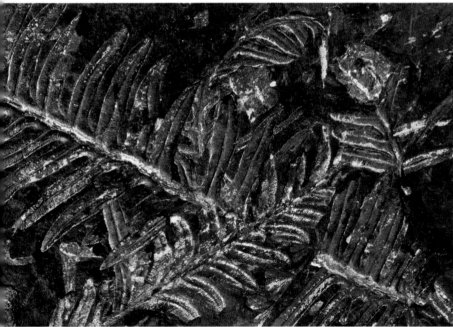

The Pennsylvania Lumber Museum in Potter County documents the massive lumber industry of the nineteenth- and early-twentieth-century and the role it played in the state's economic development—and ecological destruction. The museum is owned by the Pennsylvania Historical and Museum Commission.

During the Carboniferous Period, 300 to 354 million years ago, the landmass that is now Pennsylvania was near the Earth's equator. During this period, extensive coalfields formed in forests containing trees such as Alethopteris seed fern, now preserved in fossils.

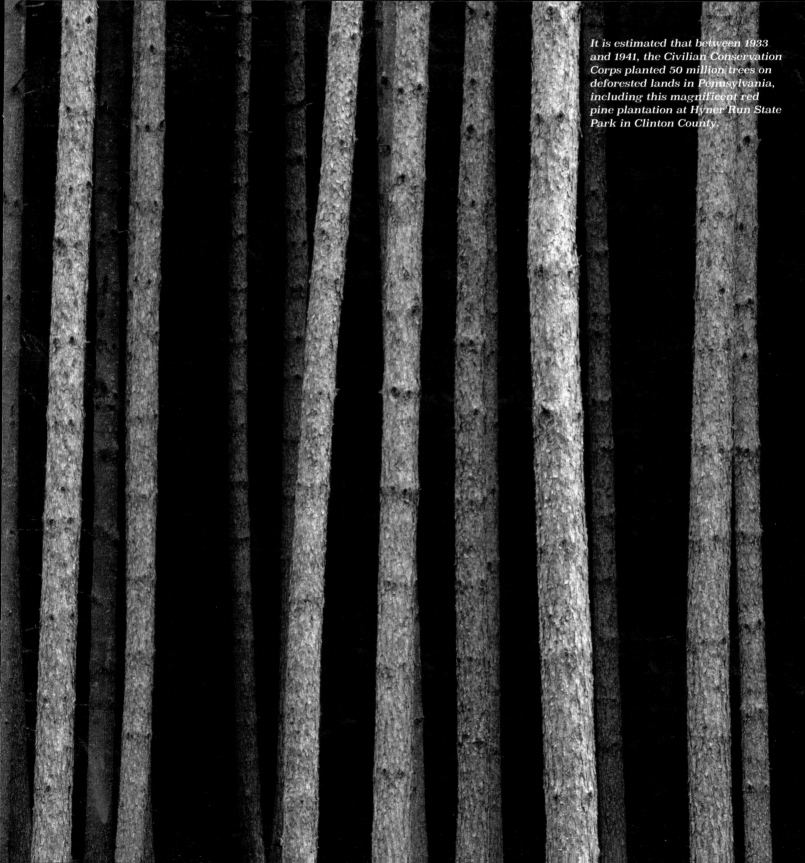

It is estimated that between 1933 and 1941, the Civilian Conservation Corps planted 50 million trees on deforested lands in Pennsylvania, including this magnificent red pine plantation at Hyner Run State Park in Clinton County.

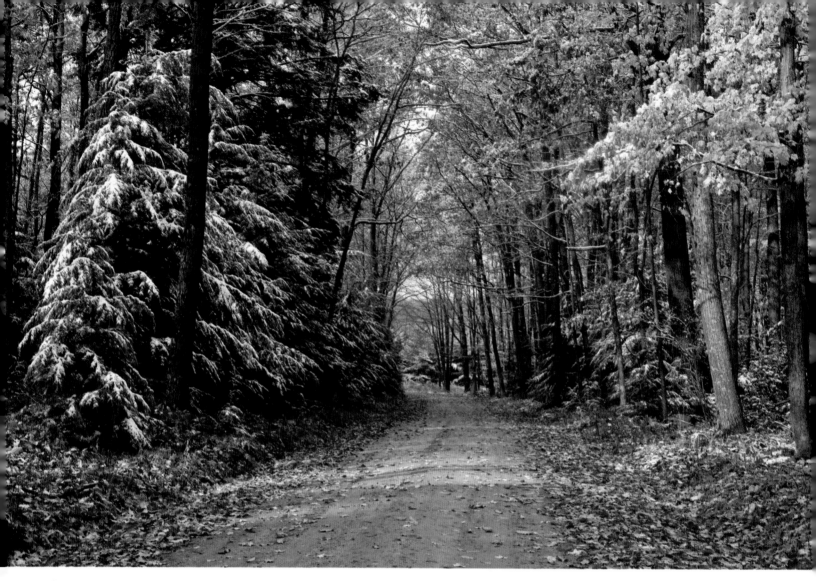

*Clear Creek State Forest is one of twenty
state forest districts in Pennsylvania. The
state has over 2.2 million acres of public
forest lands administered by the Bureau of
Forestry under the Department of
Conservation and Natural Resources.*

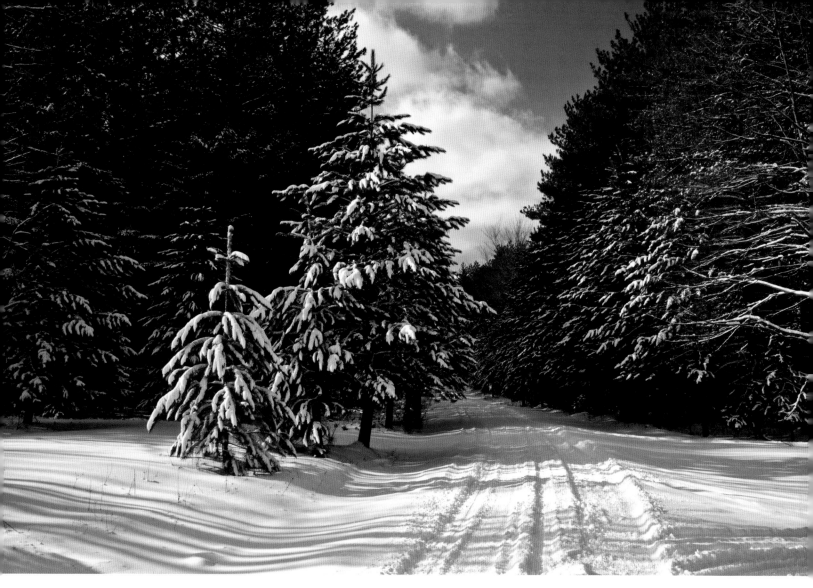

Caledonia Pike, a state forest road, runs through the 190,031-acre Moshannon State Forest in north central Pennsylvania.

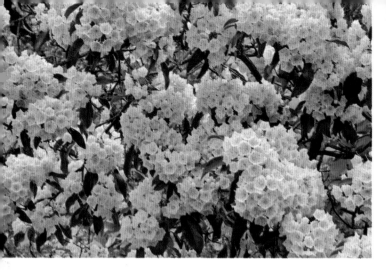

Blooming in late spring, mountain laurel (Kalmia latifolia) is considered the most beautiful native American shrub and is Pennsylvania's state flower.

Cook Forest State Park in Clarion County contains twenty-nine miles of hiking trails, some of which traverse the nine magnificent old-growth forest areas where 450-year-old trees tower to the sky.

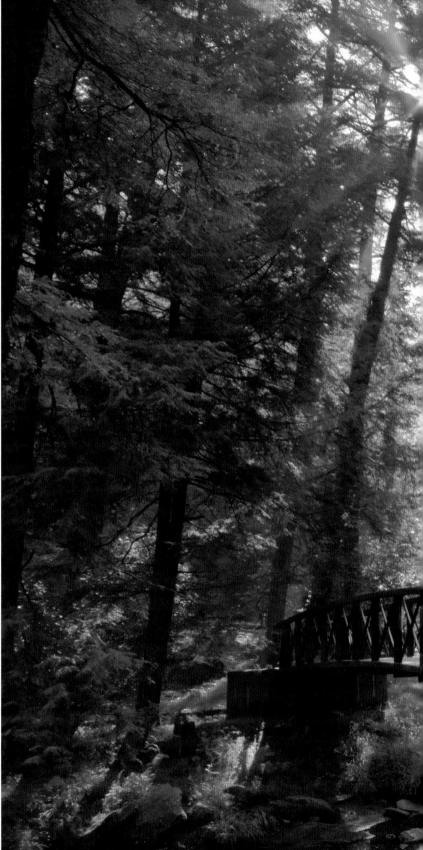

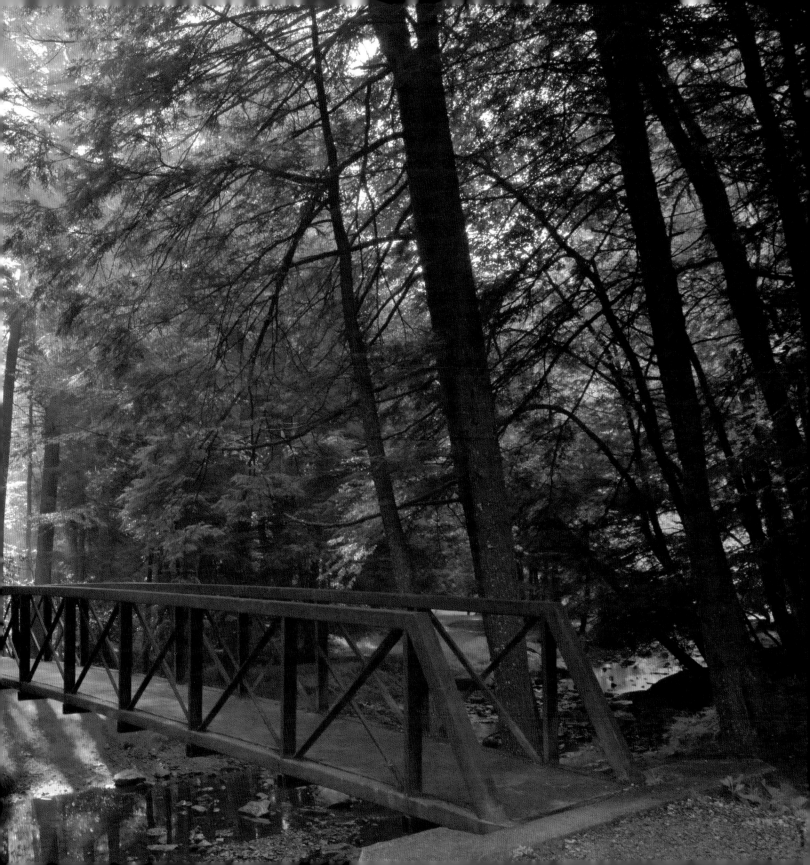

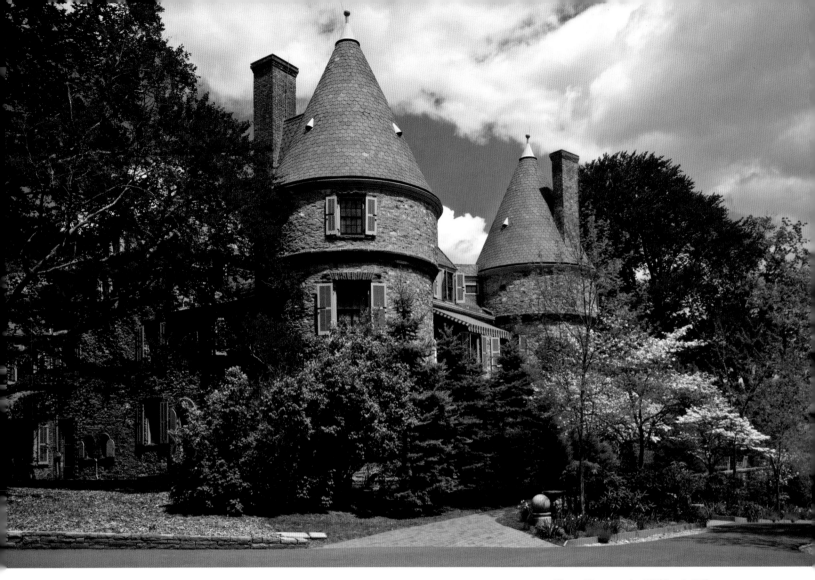

Grey Towers in Milford, Pike County, is the ancestral home of Gifford Pinchot, first US Forest Service chief and twice governor of Pennsylvania (1923–27 and 1931–35). It is now Grey Towers National Historic Site administered by the US Forest Service and home to the Pinchot Institute of Conservation.

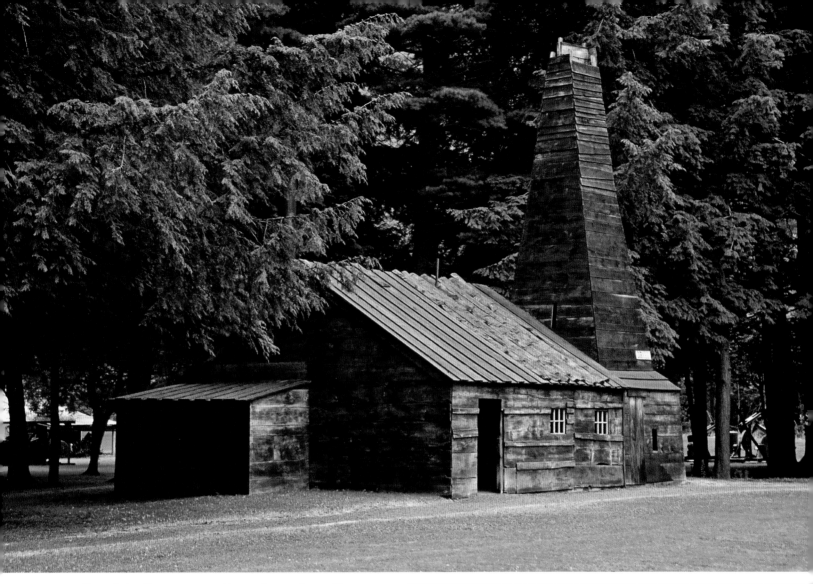

A 1945 replica of the first commercial oil well in the US, built in 1859, is on display at the Drake Well Museum in Titusville, birthplace of the oil industry.

Excursion trains still run through the valley and stop at Oil Creek State Park's Train Station in Petroleum Center just as they did over 100 years ago during the great oil boom in Venango County.

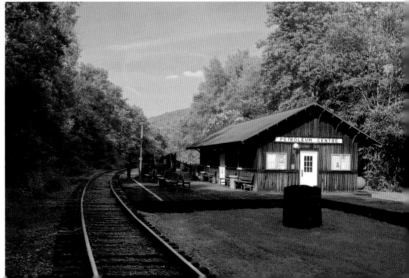

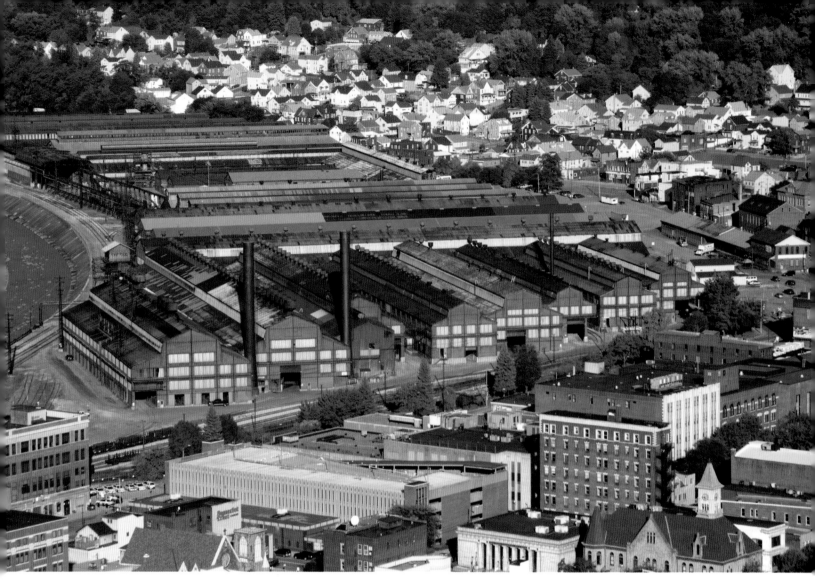

The Johnstown Inclined Plane's observation deck offers an outstanding view of the steel mills 530 feet below.

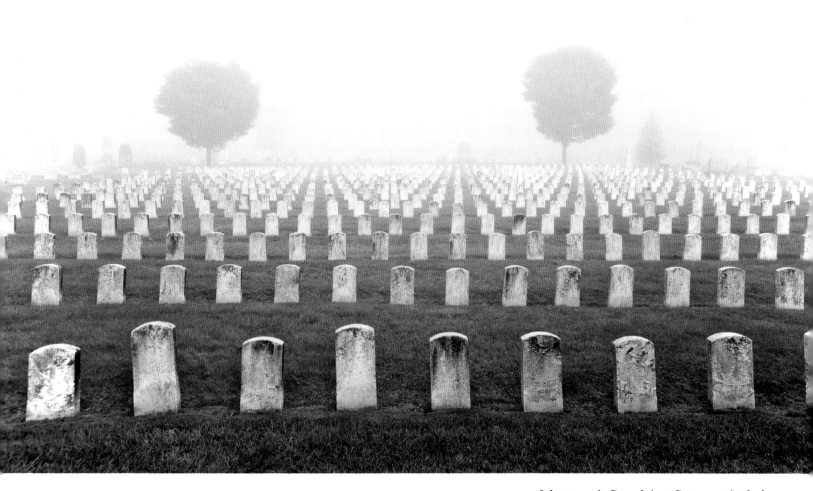

Johnstown's Grandview Cemetery includes the "Unknown Plot," which contains the interred bodies of 777 victims who could not be identified from the great 1889 Johnstown Flood. These unidentified men, women, and children were mostly immigrants and represent over one-third of the flood's 2,209 victims.

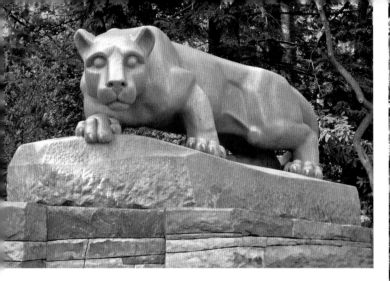

The Nittany Lion Shrine, by sculptor Heinz Warneke, was a gift to Penn State from the class of 1940. It is said to be the second most photographed landmark in Pennsylvania, after the Liberty Bell.

Penn State students enjoy a spring day on the lawn of "Old Main" at Pennsylvania State University in State College. Constructed in 1863, it was the first significant building at the school, then called the Agricultural College of Pennsylvania.

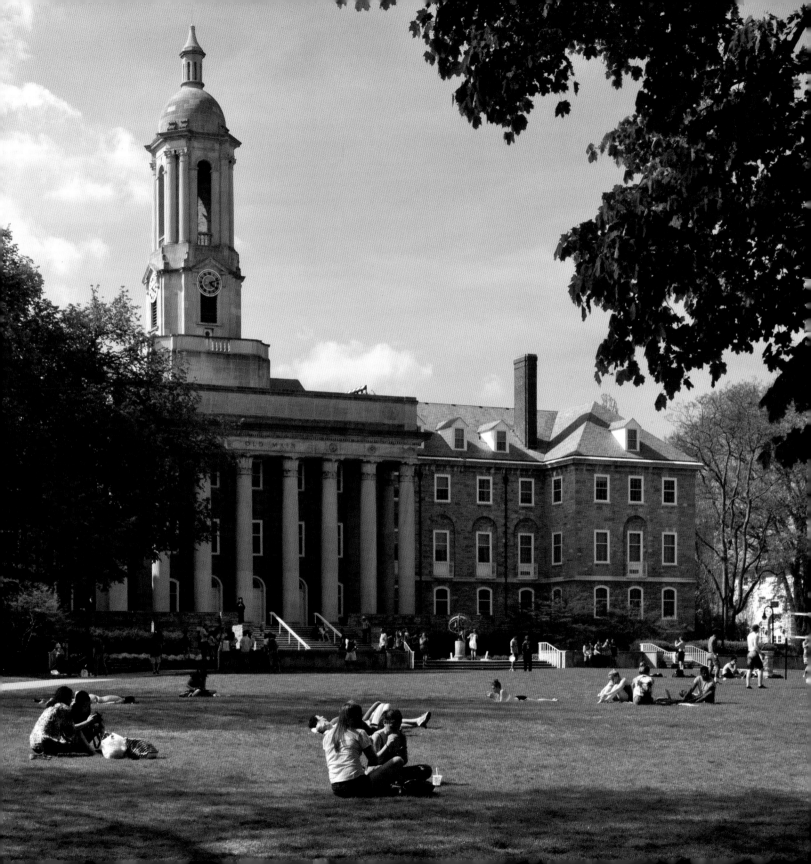

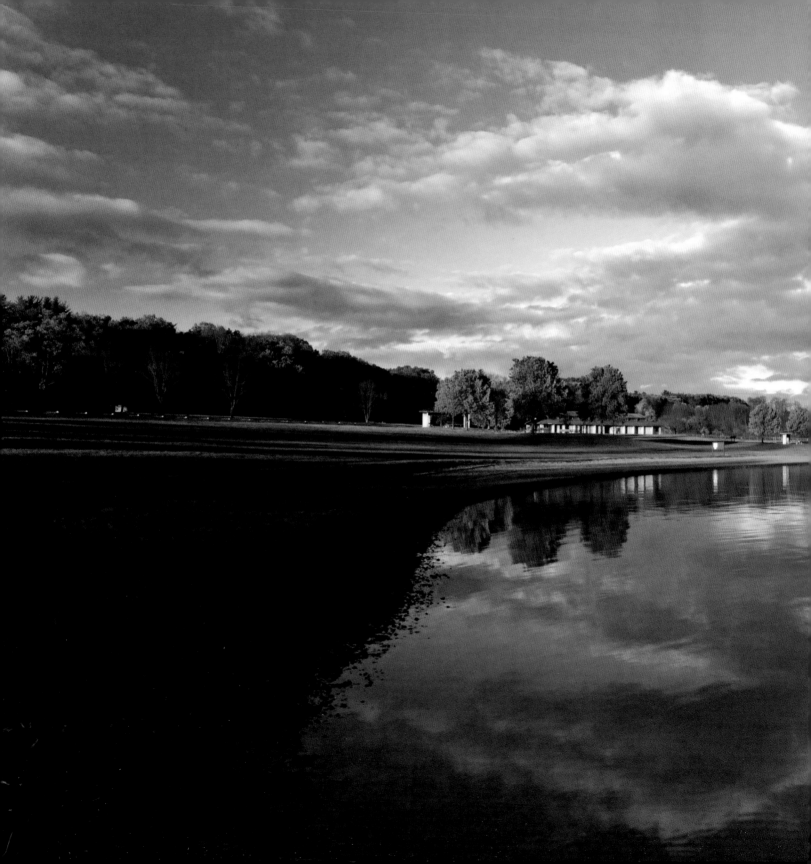

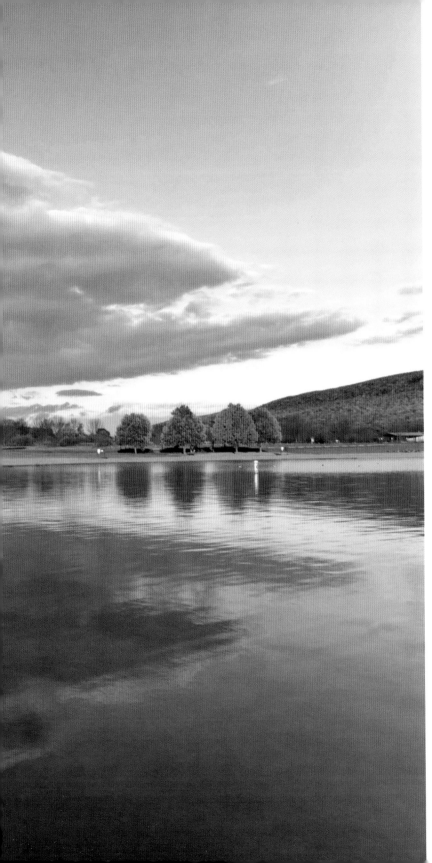

Bald Eagle State Park in Centre County is seen here on a quiet November day. Although Pennsylvania is only the thirty-third largest state, it has 120 state parks. Only Alaska and California have more acreage in parklands.

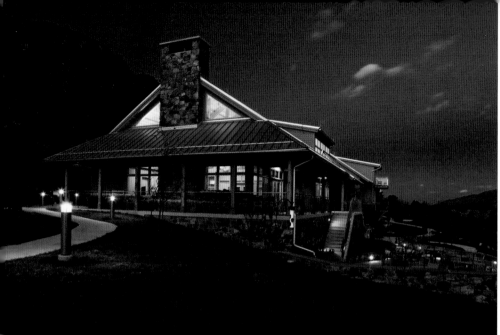

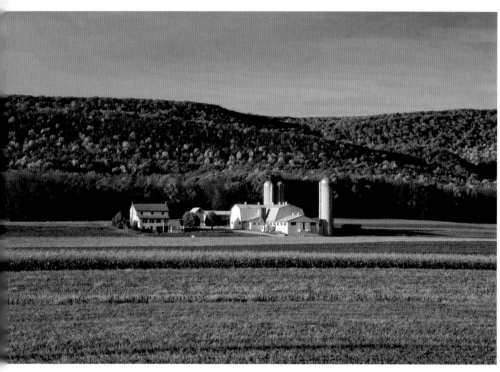

Most Pennsylvania state parks offer rustic and semi-rustic accommodations. The Nature Inn at Bald Eagle State Park is different, offering B&B amenities with double rooms, suites, flat-screen televisions, and breakfast outdoors. It is also one of the "greenest" buildings in Pennsylvania.

Agriculture is a top industry with over 63,000 farms, most of them family owned. Crop and livestock sales total nearly 400 billion dollars annually.

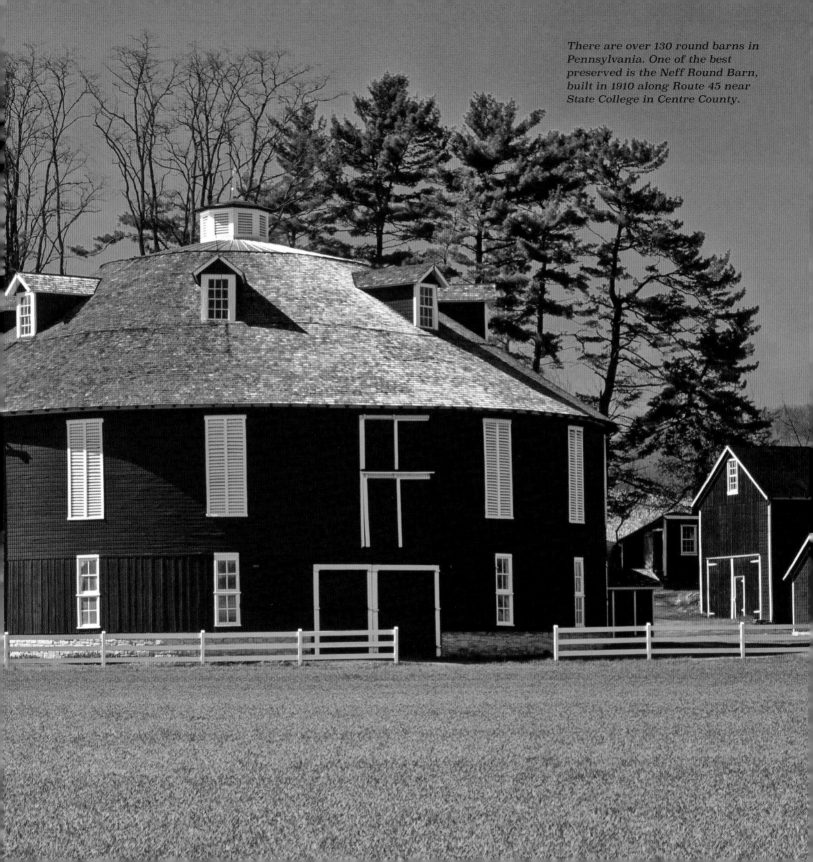

There are over 130 round barns in
Pennsylvania. One of the best
preserved is the Neff Round Barn,
built in 1910 along Route 45 near
State College in Centre County.

Although only twenty-seven percent of Pennsylvania's population is rural, seventy-five percent of its land mass is rural, consisting of more than 950 boroughs such as Blain in Perry County. A borough is a self-governing municipal entity, larger than a village, yet smaller than a city.

A drive down any country road will likely reveal a picturesque church like the Sheaffer's Valley Church of God in Perry County. These churches are often the foundation of the community.

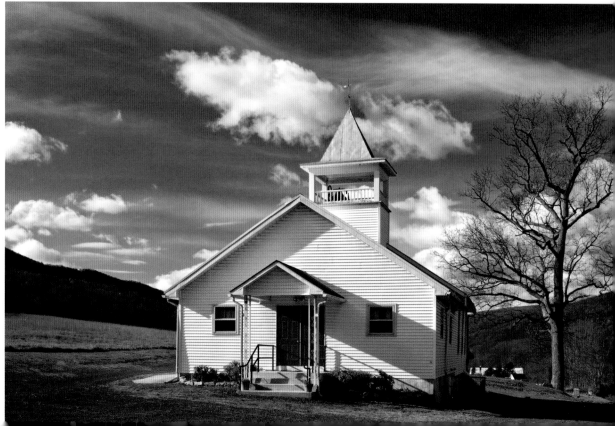

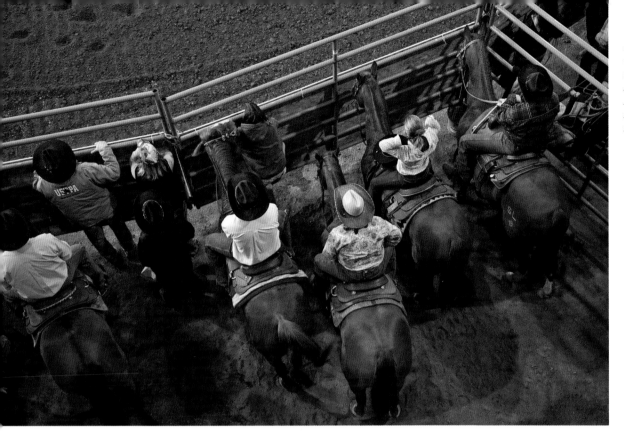

Competitors prepare for the next event in the equine competition at the annual Pennsylvania Farm Show, the largest indoor agriculture event in the US.

Adams County stakes claim to being the state's largest apple producer and the fourth largest in the United States.

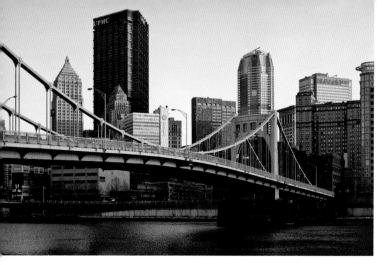

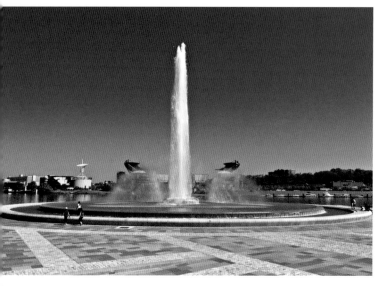

The Andy Warhol, or 7th Street, Bridge spans the Allegheny River. Pittsburgh has 446 bridges, more than any city in the world.

The 150-foot-high fountain is the centerpiece at Point State Park. The park is at the tip of Pittsburgh's Golden Triangle where the Allegheny and Monongahela Rivers join to form the Ohio River.

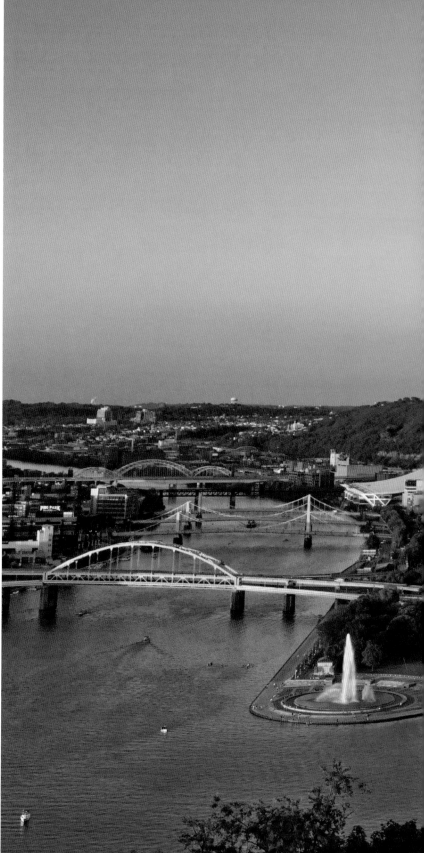

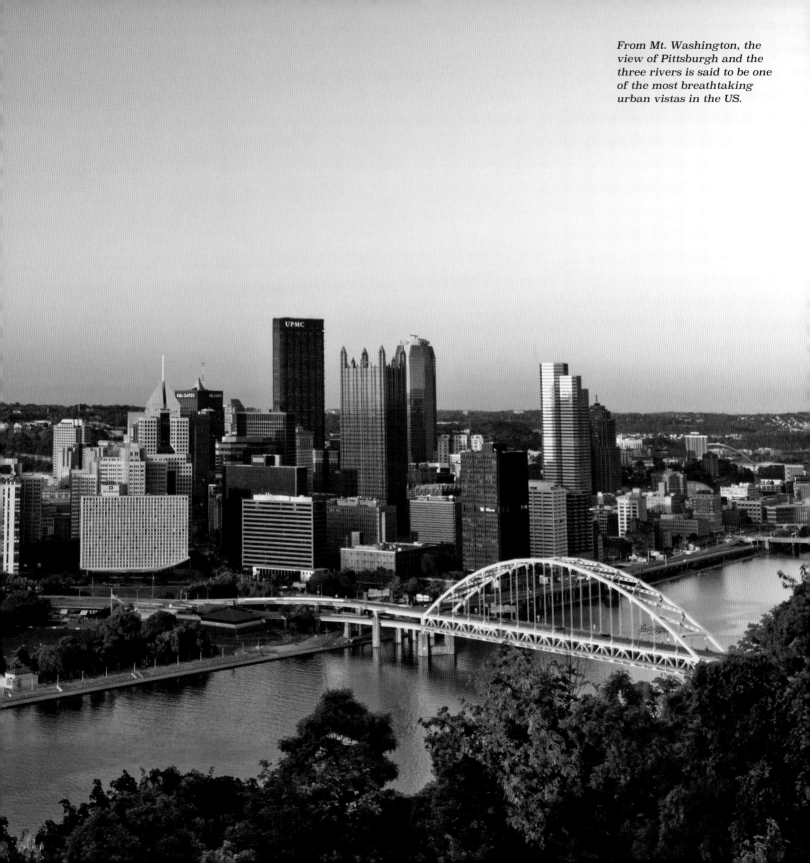

From Mt. Washington, the view of Pittsburgh and the three rivers is said to be one of the most breathtaking urban vistas in the US.

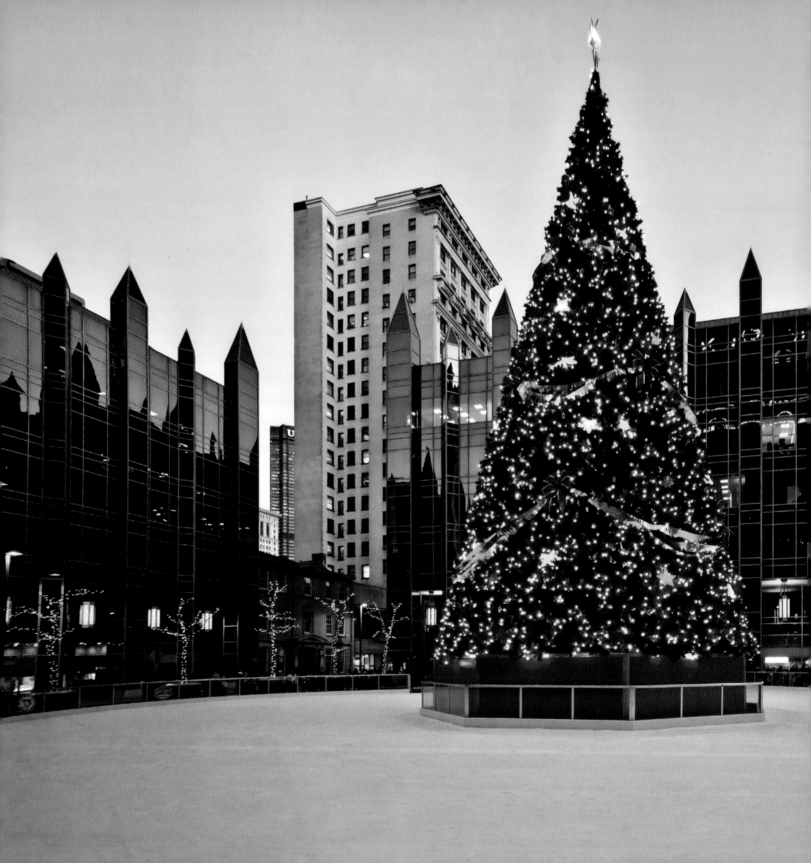

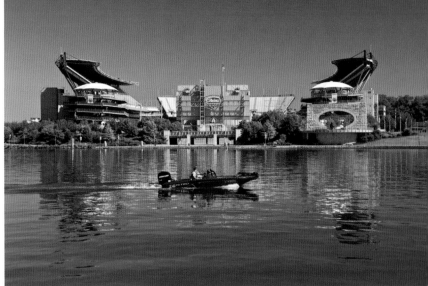

Heinz Field, on the banks of the Ohio River, is home to the Pittsburgh Steelers and University of Pittsburgh Panthers football teams. The once-polluted rivers are now so clean they are highly valued for recreational fishing and boating.

Mid-November through March 1, the Plaza at PPG Place in Pittsburgh is transformed into a 10,816-square-foot ice-skating rink with a sixty-five-foot Christmas tree at its center.

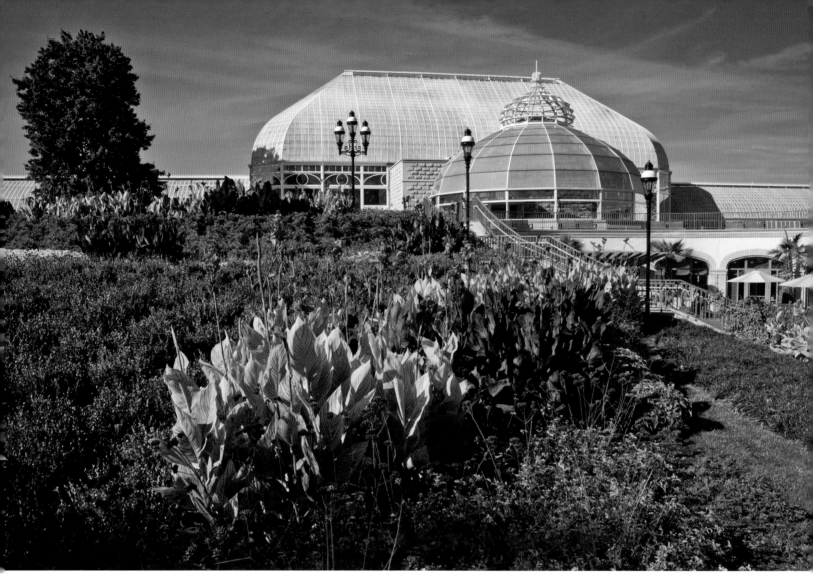

Pittsburgh's Phipps Conservancy and
Botanical Gardens was established in
1893. Recent renovations have made it
one of "greenest" facilities in the world
due to its design and infrastructure. It
received top sustainability
certifications including Living
Building Challenge, LEED Platinum,
Four Stars Sustainable SITES
Initiative, and Well Building Platinum.

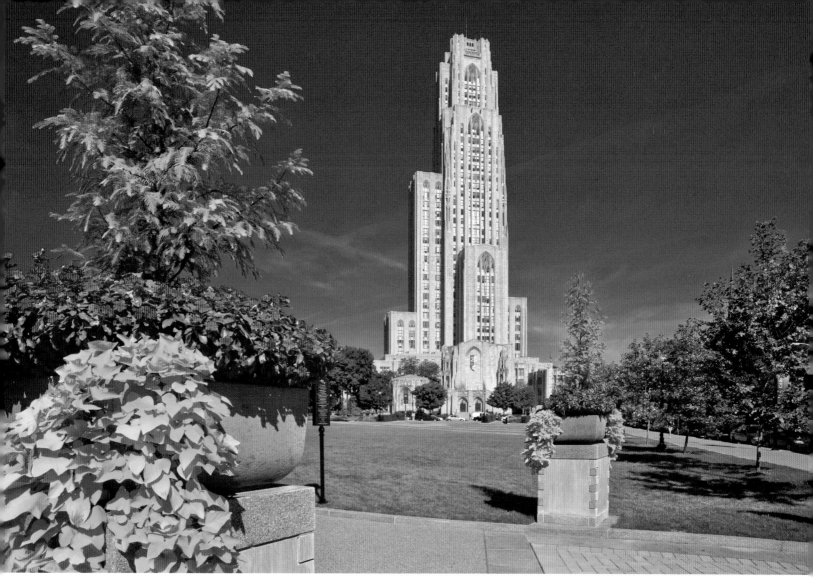

The University of Pittsburgh's Cathedral of Learning, rising 535 feet, is the tallest educational building in the Western Hemisphere and the second tallest university building in the world.

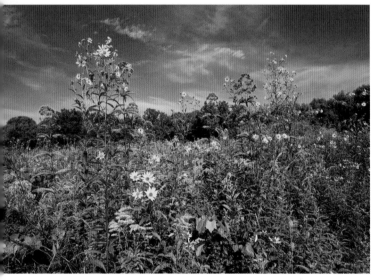

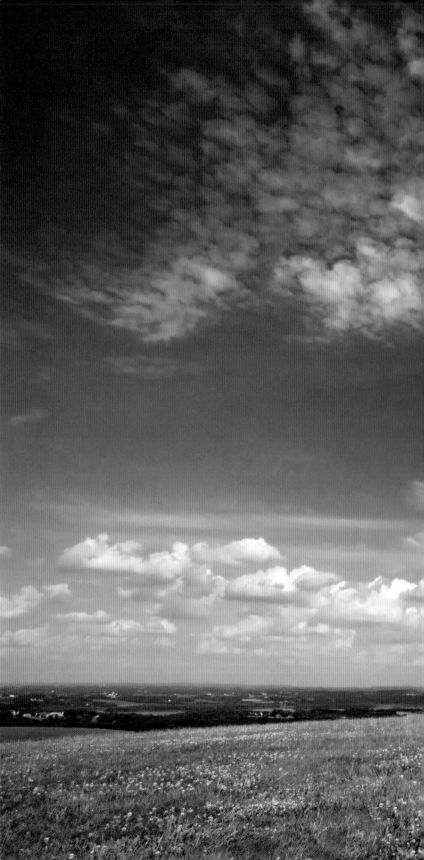

This five-room farmhouse in Springdale, northeast of Pittsburgh along the Allegheny River, was the birthplace and childhood home of Rachel Carson. In 1962, she wrote the ground-breaking book Silent Spring, credited as initiating the modern environmental movement.

Jennings Environmental Education Center is a state park in Butler County. Its 300 acres contain a rare, twenty-acre eastern prairie ecosystem with native plants like blazing star (Liatris spicata) and animals including the shy, endangered eastern massasauga rattlesnake (Sistrurus catenatus). It is the only publicly protected prairie in Pennsylvania.

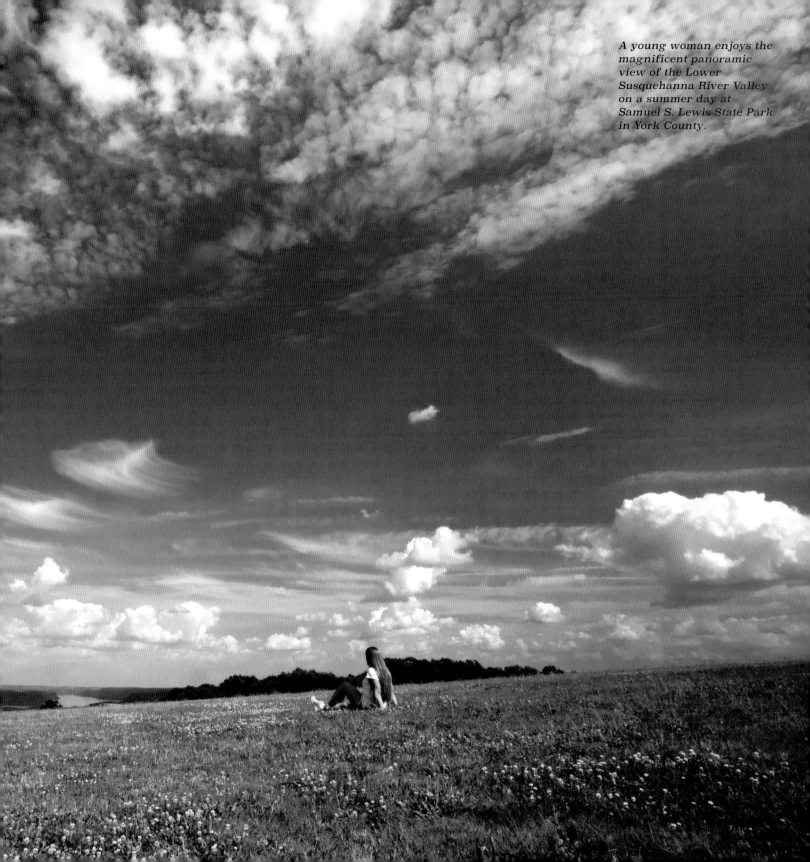

A young woman enjoys the magnificent panoramic view of the Lower Susquehanna River Valley on a summer day at Samuel S. Lewis State Park in York County.

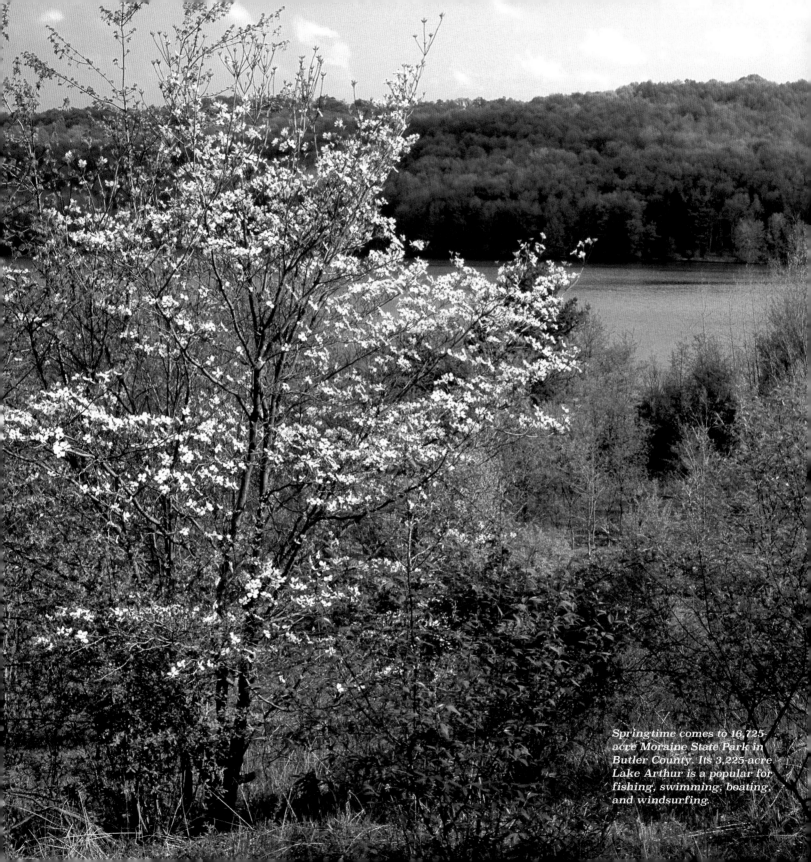

Springtime comes to 16,725-acre Moraine State Park in Butler County. Its 3,225-acre Lake Arthur is a popular for fishing, swimming, boating, and windsurfing.

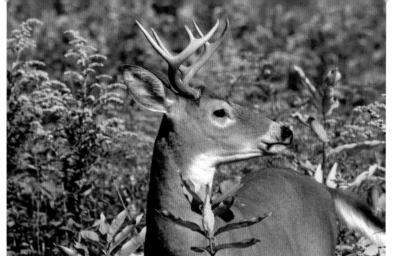

The white-tailed deer (Odocoileus virginianus) was designated the state mammal on October 2, 1959. It was important in the commonwealth's early settlement, with "buckskins" used in place of money. Today it is probably the state's most popular game animal with over 350,000 harvested by hunters annually

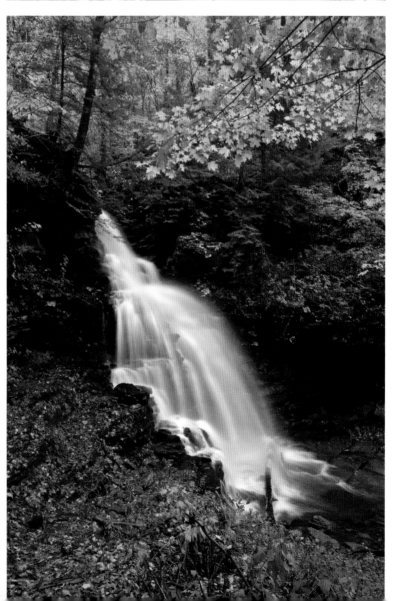

A rare old-growth forest and twenty-four named waterfalls are some of the wonders of the 13,050-acre Ricketts Glen State Park encompassing Luzerne, Sullivan, and Columbia Counties. The site was approved as a national park in the 1930s, but World War II altered the plans and instead the site was sold to the commonwealth.

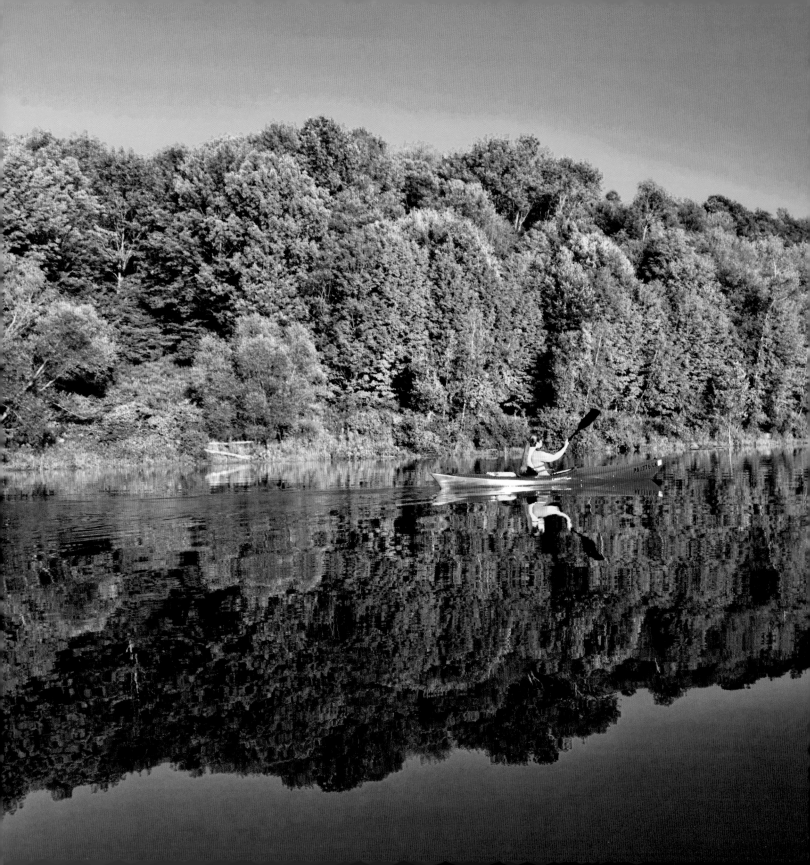

The 290-acre Prompton Lake in Wayne County provides mirror-like waters for a kayaker. The lake, maintained by the US Army Corps of Engineers, is at the center of 2,000-acre Prompton State Park.

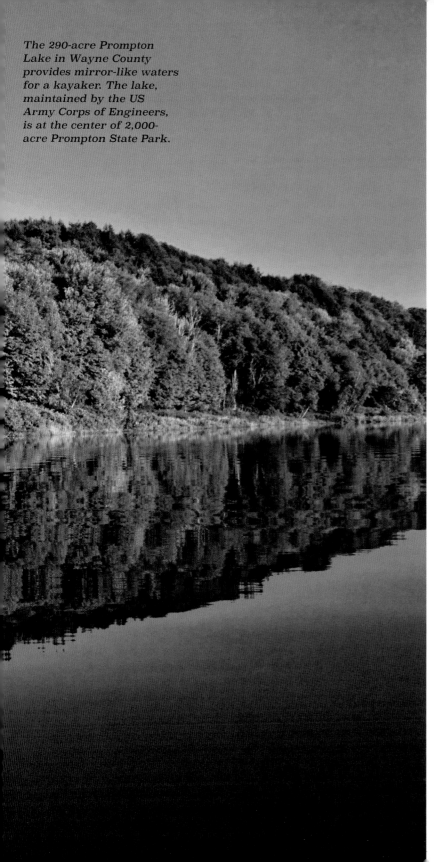

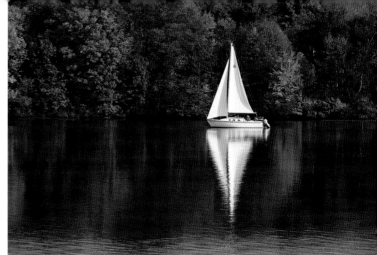

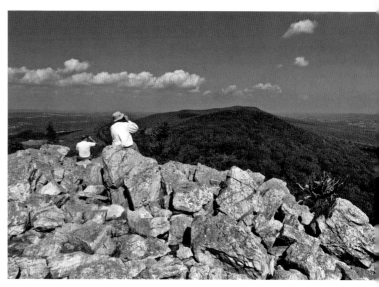

Surrounded by southeastern Pennsylvania's urban sprawl, 1,450-acre Lake Nockamixon, at Nockamixon State Park in Bucks County, is an outdoor oasis accessible to millions of people living in greater Philadelphia.

Sitting at an elevation of 1,521 feet along the Kittatinny Ridge, the North Lookout at Hawk Mountain Sanctuary is a world-renowned observation site for autumn migration raptors. An average of 20,000 hawks, eagles, and falcons are observed yearly. Established in 1934, the sanctuary straddles Berks and Schuylkill Counties.

More than 229 miles of the world-famous Appalachian Trail pass through Pennsylvania. A hiker pauses to enjoy a breathtaking view of the Delaware Water Gap from Mount Minsi.

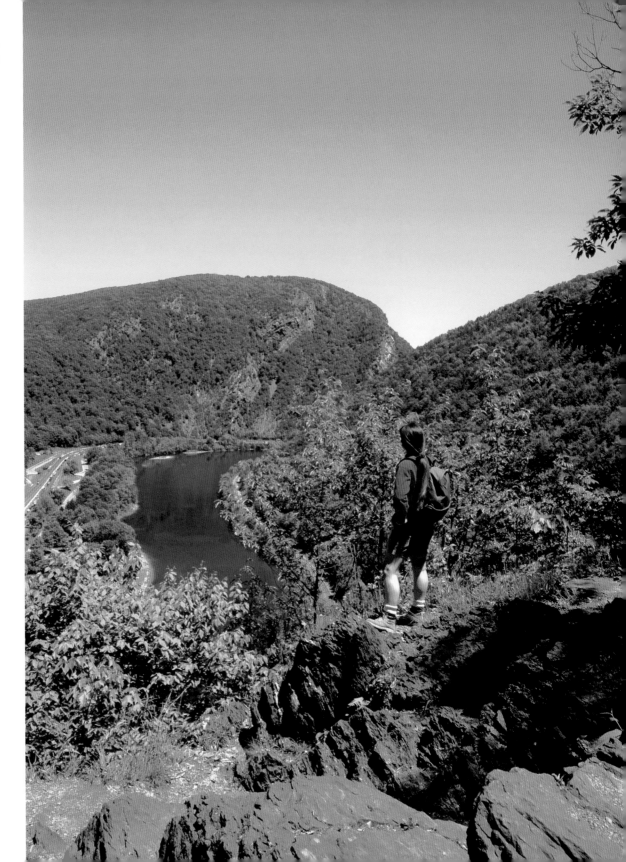

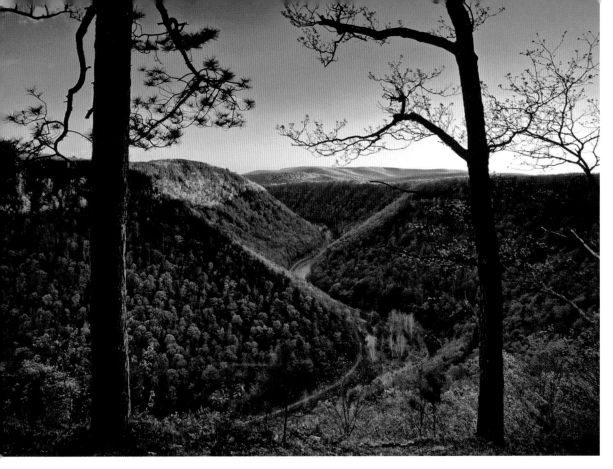

The forty-five-mile-long Pine Creek Gorge in Tioga County is often referred to as the Grand Canyon of Pennsylvania. It is 1,450 feet deep at its deepest point and 4,000 feet from rim to rim. The gorge is a National Natural Landmark.

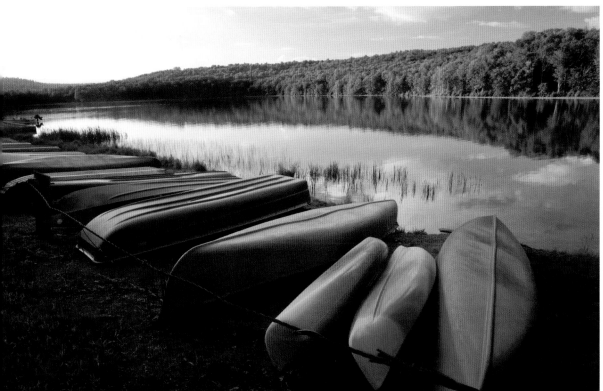

One of forty-seven lake areas owned by the Pennsylvania Fish & Boat Commission, Hunter Lake and its surrounding 2,000 acres in Sullivan County offers recreational fishing and boating and provides valuable water resources for wildlife and local fire companies.

The Hillsgrove Union Church in Sullivan County braves a February snowstorm. Sullivan County is the second-least populous county in Pennsylvania.

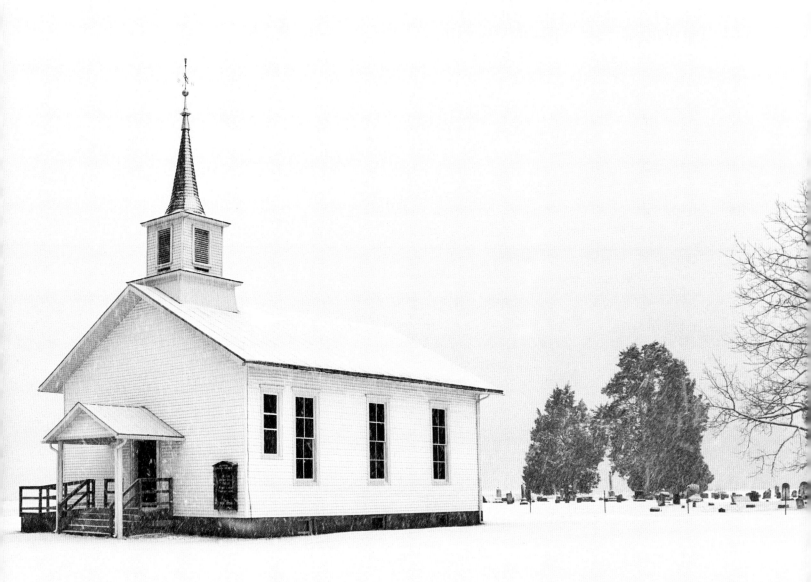

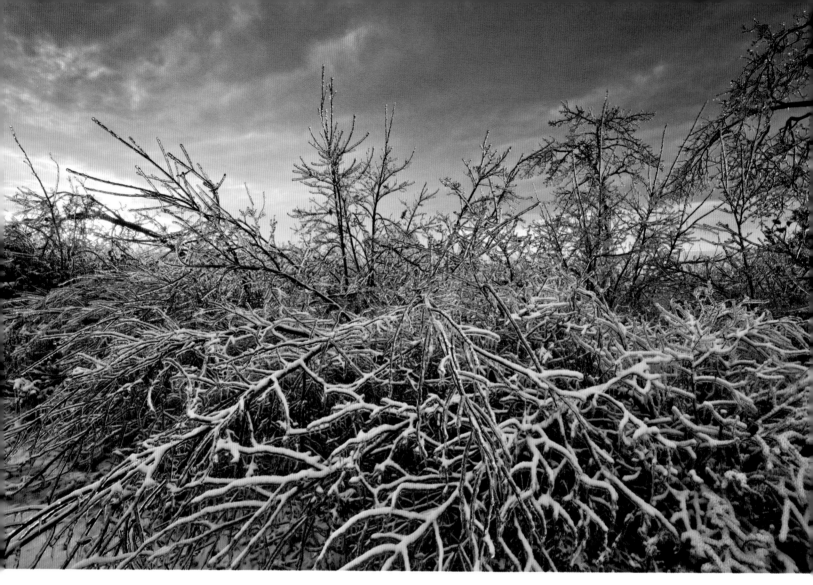

A mid-December ice storm on Moosic Mountain in Lackawanna County has bent the gray birch trees (Betula populifolia) to nearly ground level. After the ice melts, the trees regain their upright position.

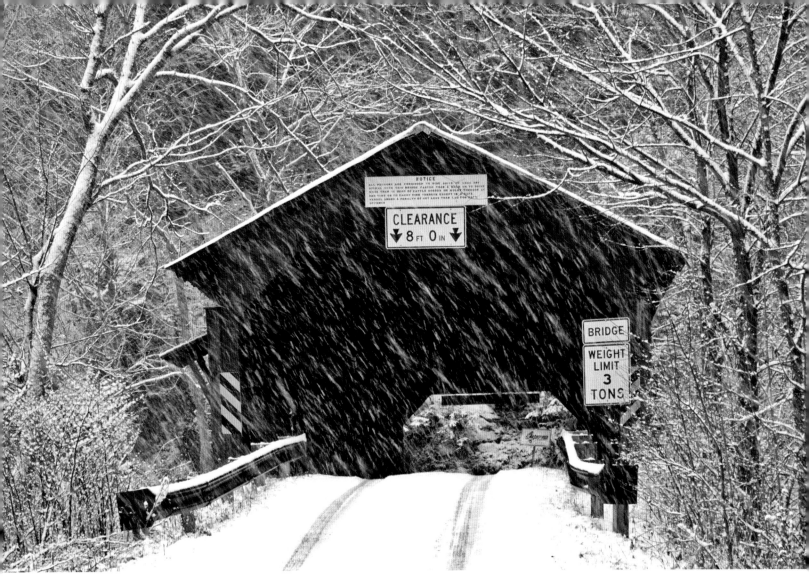

NOTICE

ALL PERSONS ARE FORBIDDEN TO RIDE DRIVE OR LEAD ANY ANIMAL OVER THIS BRIDGE FASTER THAN A WALK OR TO DRIVE MORE THAN 15 HEAD OF CATTLE HORSES OR MULES THEREON AT ONE TIME OR TO CARRY FIRE THROUGH EXCEPT IN A SAFE VESSEL UNDER A PENALTY OF NOT LESS THAN $5.00 FOR EACH OFFENCE

CLEARANCE
▼ 8 FT 0 IN ▼

BRIDGE

WEIGHT
LIMIT
3
TONS

The Hillsgrove/Rinkers Covered Bridge, in Sullivan County, was built in 1850 and spans 186 feet across the Loyalsock Creek. Pennsylvania has nearly 200 covered bridges, more than any other state.

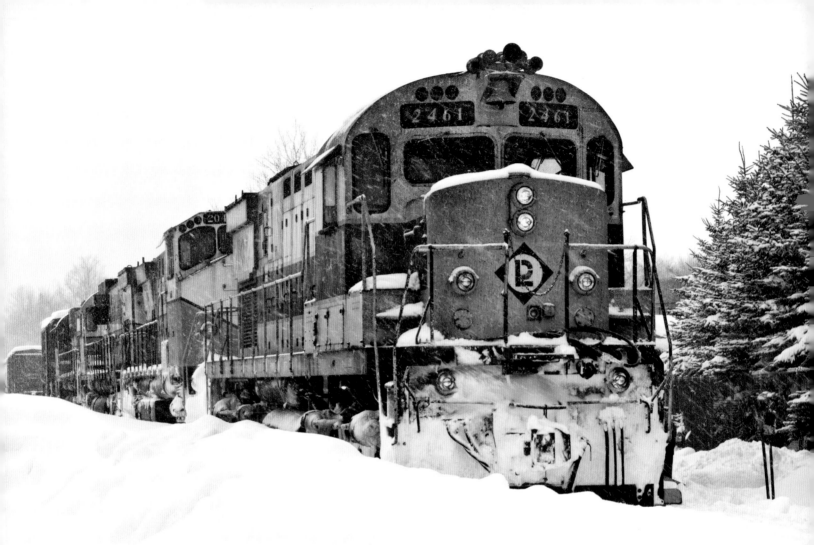

Pennsylvania railroads continue to play an important role in the nation's growth and prosperity. The first steam locomotive to operate in the United States was the Stourbridge Lion in Honesdale, Wayne County on August 8, 1829.

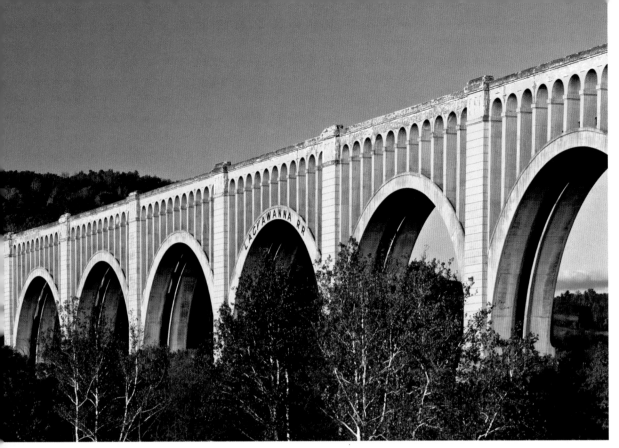

Built by the Delaware, Lackawanna and Western Railroad (DL&W), the 2,375-foot-long, 240-foot-high Tunkhannock Creek Viaduct in Nicholson, Wyoming County, was the largest concrete structure in the world when it was completed in 1915. It is still used for through-rail freight service.

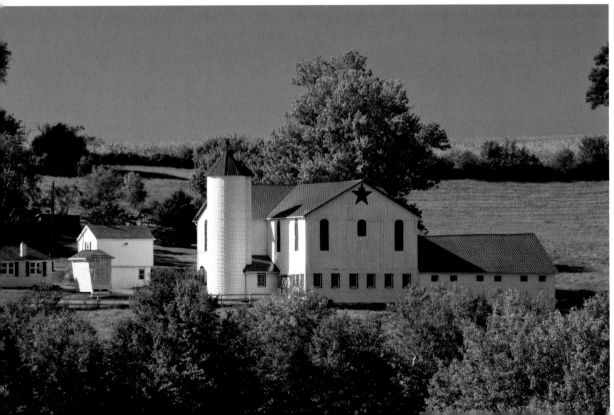

Driving Pennsylvania's back roads can reveal many secrets and surprises, such as this unique star barn in Armstrong County.

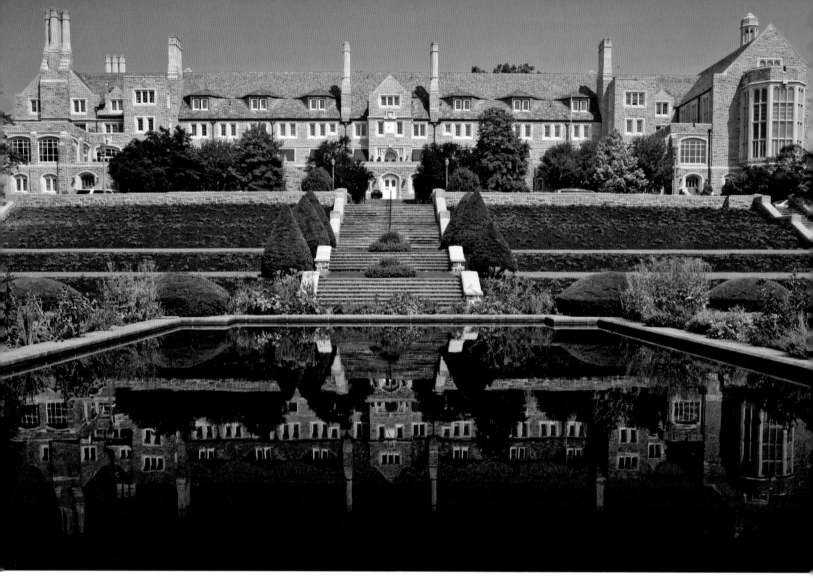

The Freemason mansion and the Masonic Homes in Elizabethtown, Lancaster County, is a continuing care retirement community, children's home, and community service organization. It is owned and operated by the Right Worshipful Grand Lodge of Free and Accepted Masons of Pennsylvania.

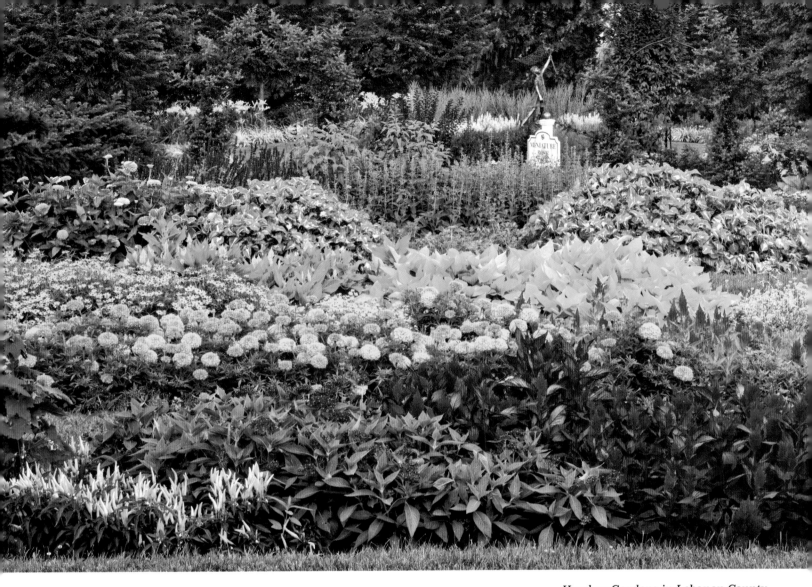

Hershey Gardens in Lebanon County features a magnificent assortment of flowers, shrubs, and trees, including a children's garden and a butterfly house. Covering twenty-three acres and overlooking Hershey, it began with a simple three-and-a-half-acre rose garden in 1937.

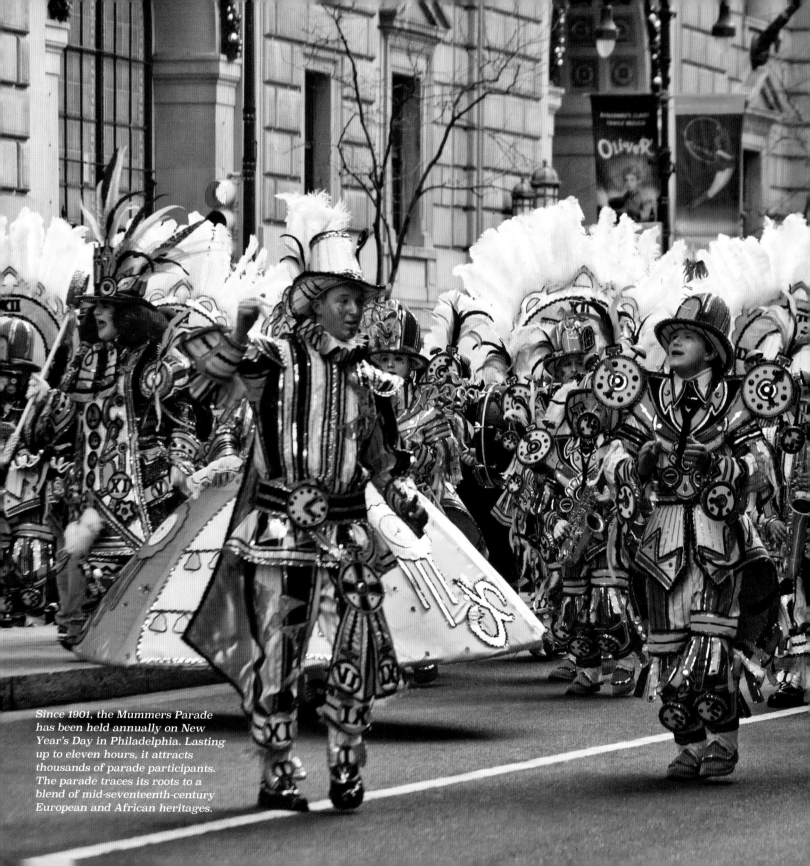

Since 1901, the Mummers Parade has been held annually on New Year's Day in Philadelphia. Lasting up to eleven hours, it attracts thousands of parade participants. The parade traces its roots to a blend of mid-seventeenth-century European and African heritages.

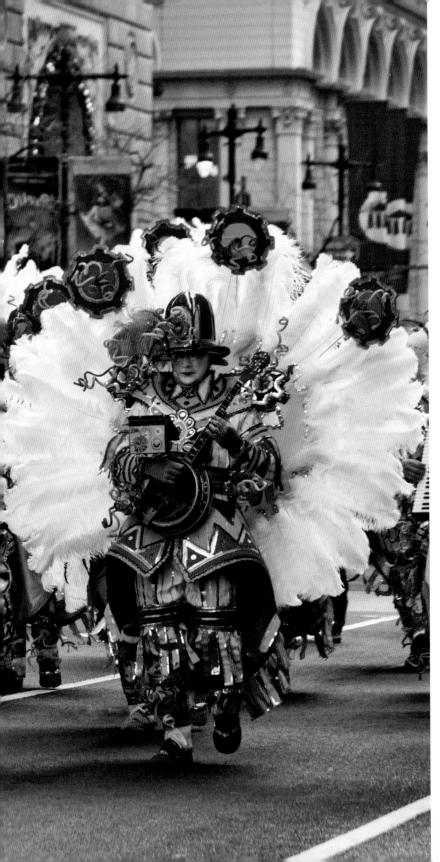

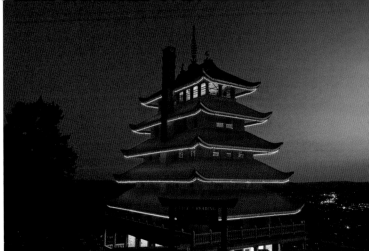

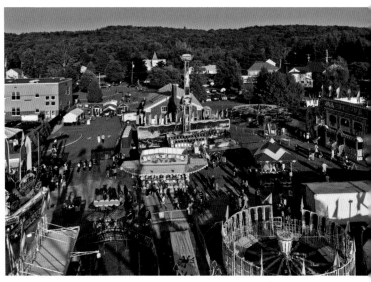

Standing atop Mt. Penn, 620 feet above Reading, the Pagoda has served as a historical landmark and shining beacon for Greater Reading since 1908. Originally intended to be a luxury resort, it is owned and cared for by the citizens and the city.

Summer fairs and carnivals are a traditional summer pastime. The Pennsylvania Department of Agriculture lists 109 county and community fairs across Pennsylvania, including the Greene-Deher-Sterling (GDS) Fair seen here in the Poconos.

The beautifully landscaped Allentown
Arts Park, near the Allentown Art
Museum, not only provides a retreat
in the busy city but also offers
summer musical programs and live
art demonstrations.

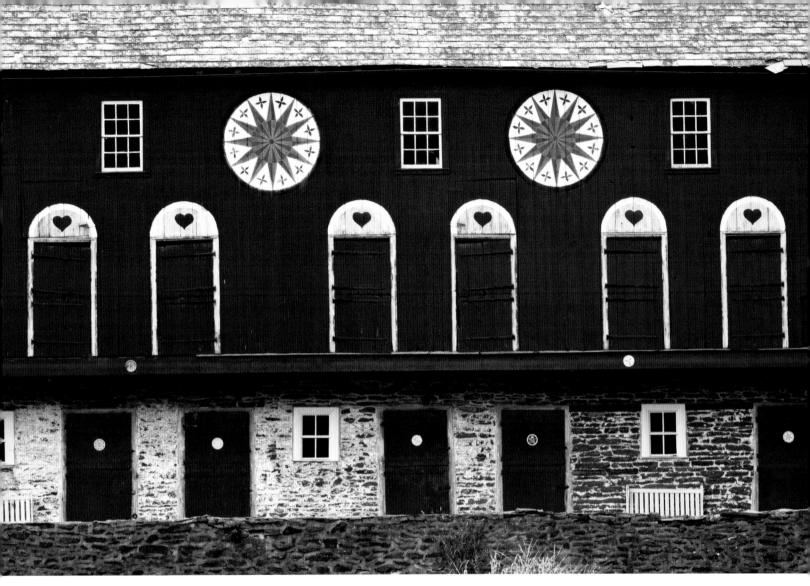

Around 1850, the Pennsylvania Dutch—actually German descendants—began painting hex signs on their barns. Some people view the signs as purely decorative, while others believe they are a talisman to protect the owner from danger or evil.

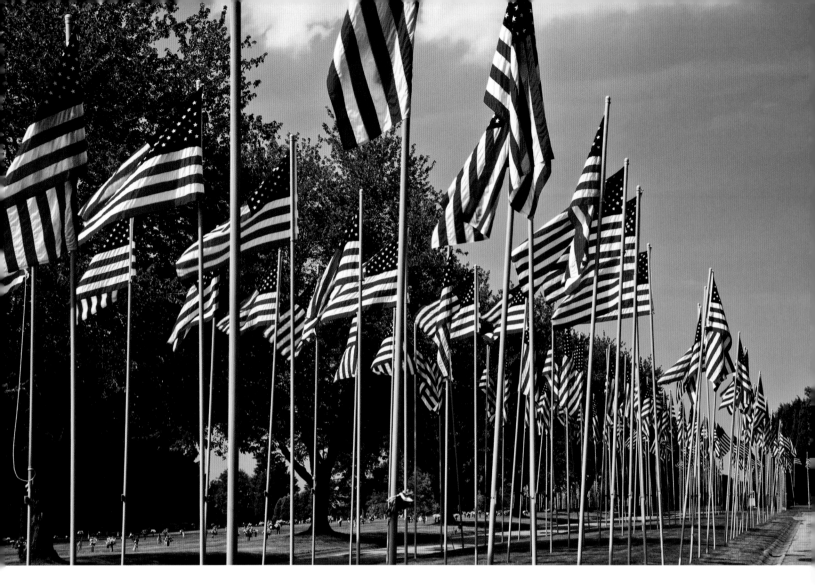

The Avenue of 444 Flags at Hillcrest
Memorial Park in Hermitage serves
as a tribute to the men and women
who have served in the United States
armed forces. One flag was raised
every day during the Iranian hostage
crisis that lasted from November 4,
1979, until January 20, 1981.

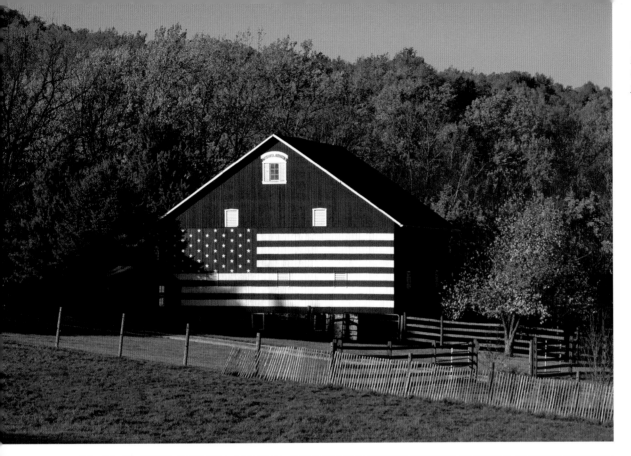

The owners of a small family farm in Adams County show their patriotism through the barn.

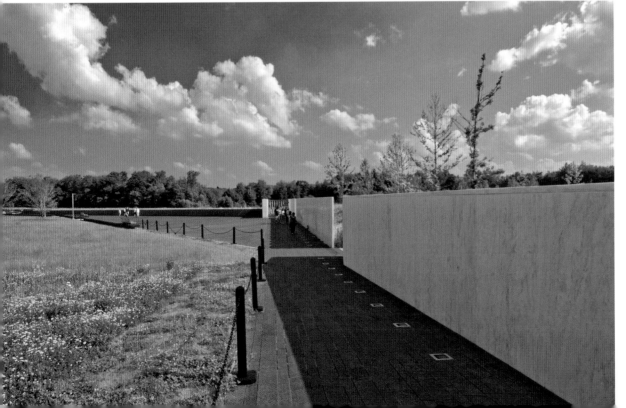

An atmosphere of profound dignity and respect envelops the Flight 93 National Memorial in Somerset County, the crash site where forty passengers and crew lost their lives on 9/11 while preventing an attack on the US Capitol.

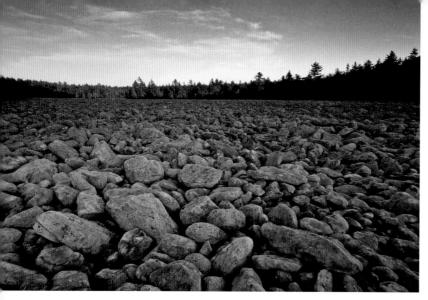

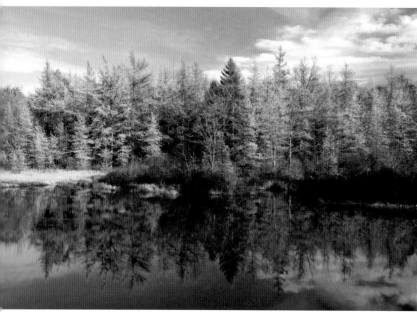

The 400-foot by 1,800-foot glacial boulder field at Hickory Run State Park was formed 20,000 years ago during the last Ice Age. It is listed as a National Natural Landmark.

The native tamarack or American larch (Larix laricina) lining Wagner's Run in the Pocono Mountains is a scene one might expect to encounter in Canada.

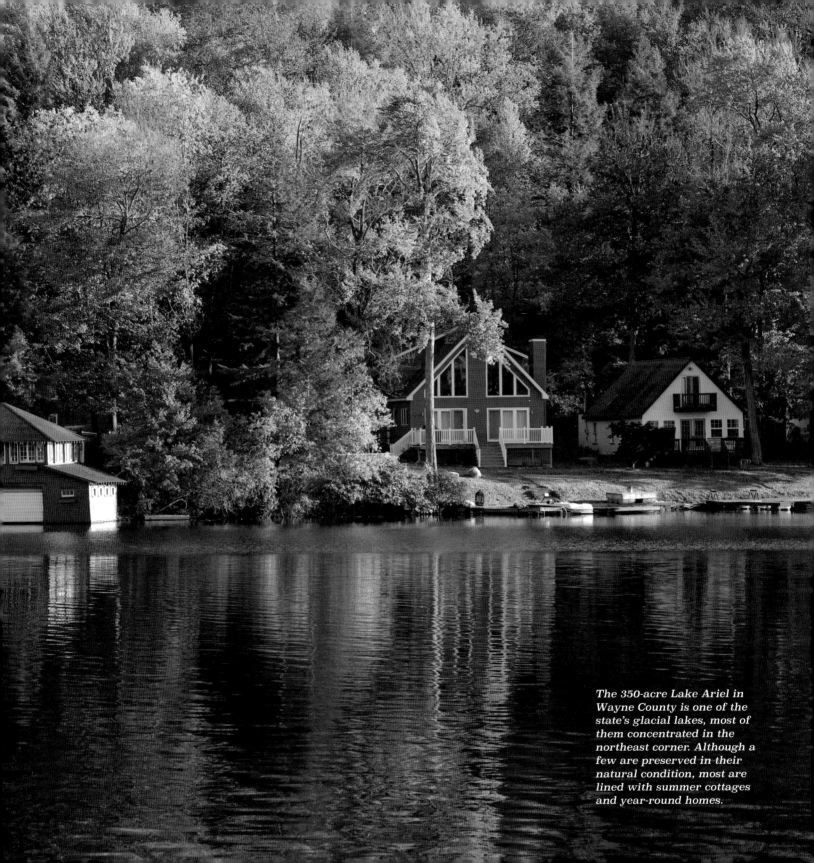

The 350-acre Lake Ariel in Wayne County is one of the state's glacial lakes, most of them concentrated in the northeast corner. Although a few are preserved in their natural condition, most are lined with summer cottages and year-round homes.

The 17,088-acre
Pymatuning Reservoir,
created in 1934 in
Crawford County, spans
the state border into
Ohio. The name
Pymatuning comes from
Lenape Native American
Chief Pihmtomink.

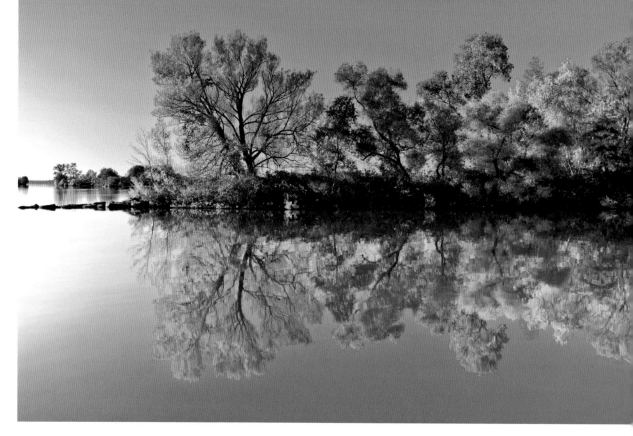

Balanced Rock at Trough
Creek State Park has
been suspended on a cliff
ledge for thousands of
years, looking like it
might fall off at any
moment. Geologists refer
to it as an "erosion
remnant" in which softer
surrounding rock has
been eroded away,
leaving a giant boulder.

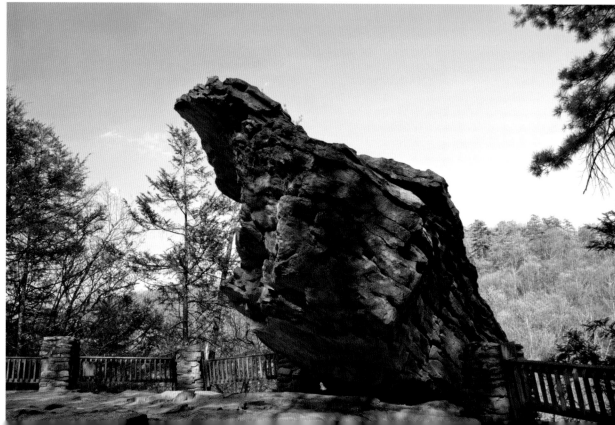

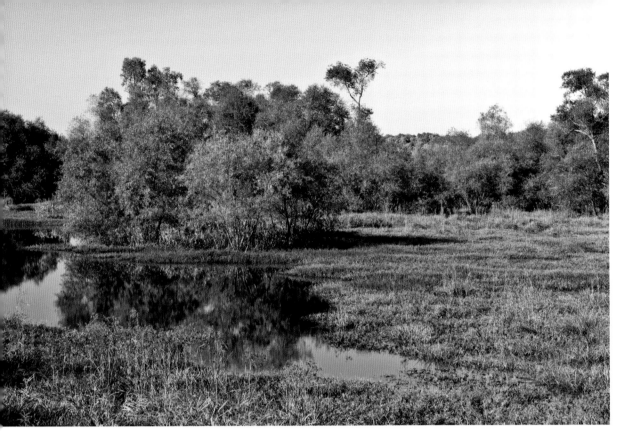

Erie National Wildlife Refuge in Crawford County is one of three national wildlife refuges in Pennsylvania. Its 8,777 acres provide vital habitat for over 237 bird species, forty-seven mammal species, and thirty-seven reptile and amphibian species.

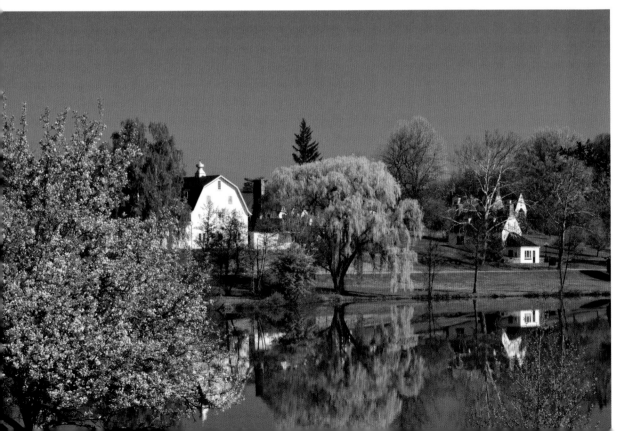

Water Brooks Farm is part of 3,983-acre Shawnee State Park in Bedford County. The house and barn, owned by John Gabbert Bowman, chancellor of the University of Pittsburgh from 1921 to 1945, sits on an island surrounded by the 451-acre Shawnee Lake.

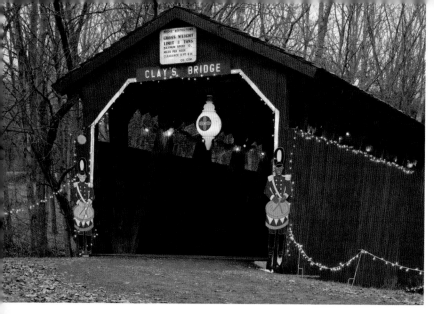

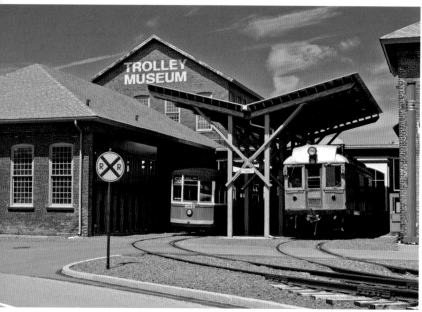

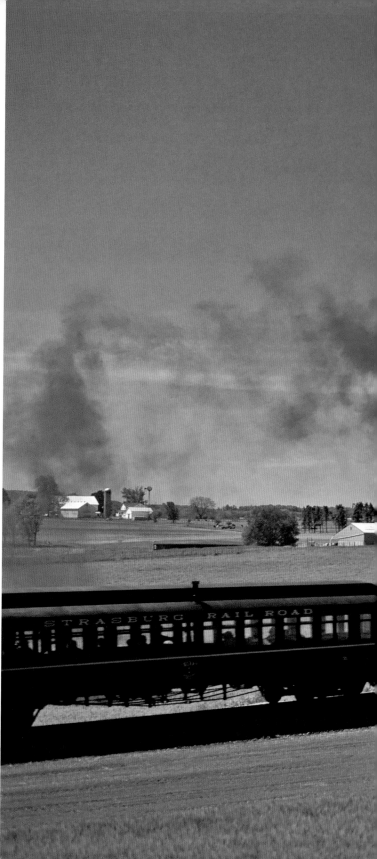

Clay's Covered Bridge at Little Buffalo State Park in Perry County is decked out for the popular Christmas Walk, when thousands of lights and holiday cutouts decorate the East Picnic Area for Santa's appearance. Local 4-H clubs sell cookies and hot chocolate while area choirs sing carols.

The Electric City Trolley Museum in Scranton, next to Steamtown National Historic Site, offers rides aboard historic trolley cars. Scranton built the first successful electric streetcar system in 1886, hence the nickname Electric City.

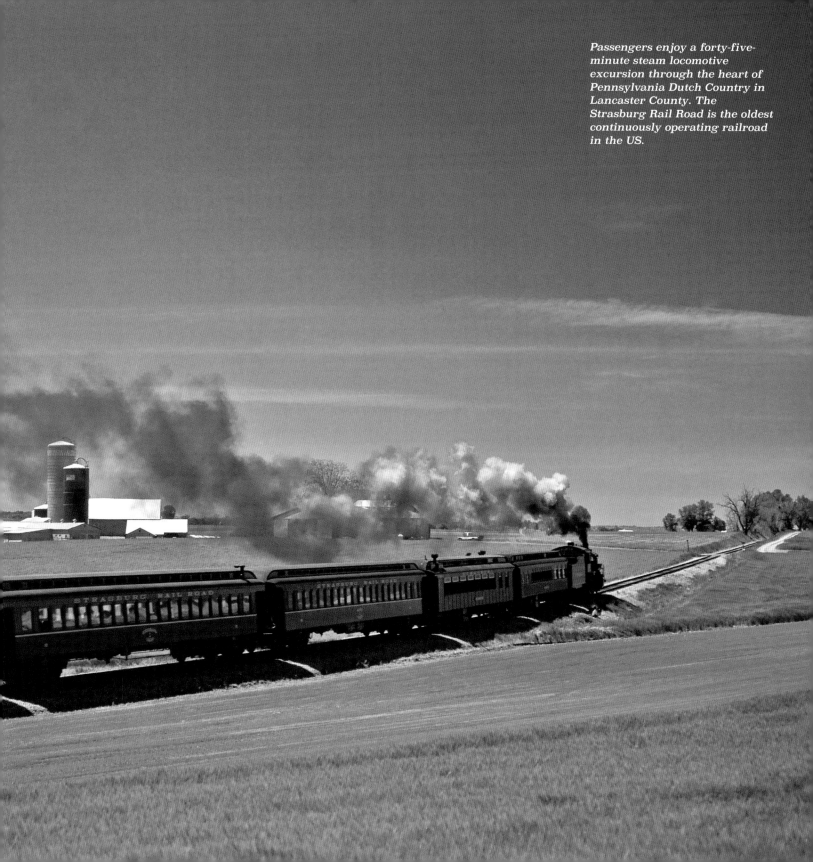

Passengers enjoy a forty-five-minute steam locomotive excursion through the heart of Pennsylvania Dutch Country in Lancaster County. The Strasburg Rail Road is the oldest continuously operating railroad in the US.

The Grand Lobby of the former Delaware, Lackawanna and Western Railroad Station in Scranton was built in 1908 and used for passenger railroad service until 1970. Listed on the National Register of Historic Places it was renovated and reopened as the Radisson Lackawanna Station Hotel in 1983.

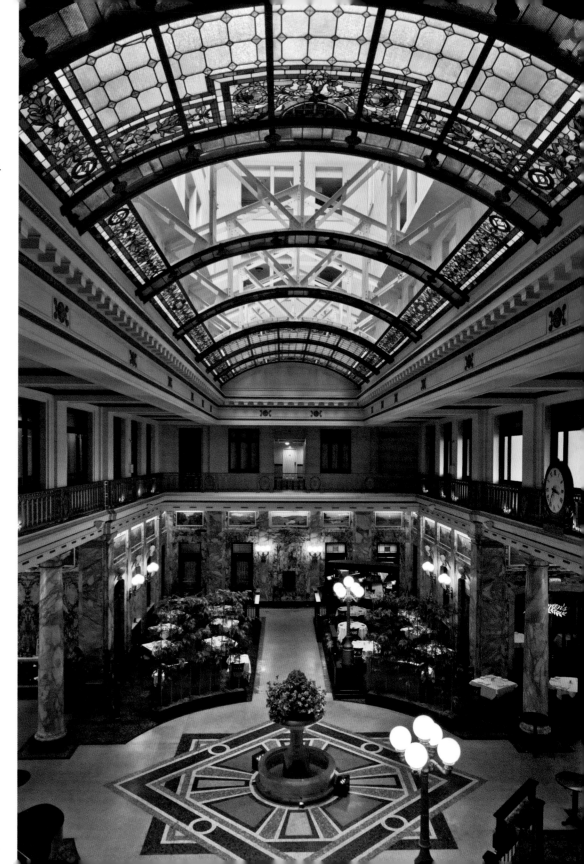

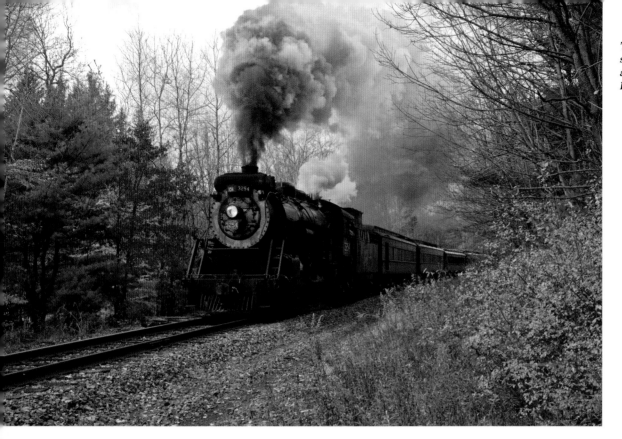

The Canadian National 3254 steam locomotive is stationed at Steamtown National Historic Site in Scranton.

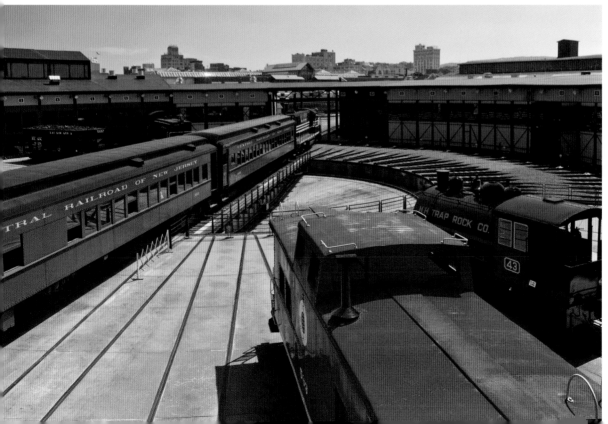

The restored roundhouse encircles the turntable at Steamtown National Historic Site in Scranton. Part of it dates to 1902. The roundhouse contains a museum complex, visitor's center, maintenance area for the train collection, and viewing platform where visitors can observe locomotives being turned around on the turntable.

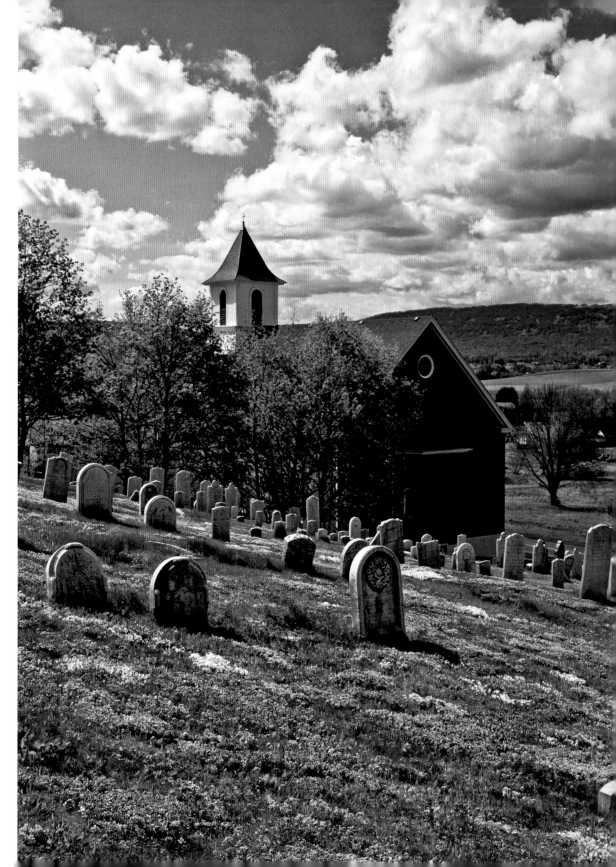

Country church cemeteries, such as St. Paul's Church of Indianland in Northampton County, provide valuable information to the growing number of people doing ancestry research.

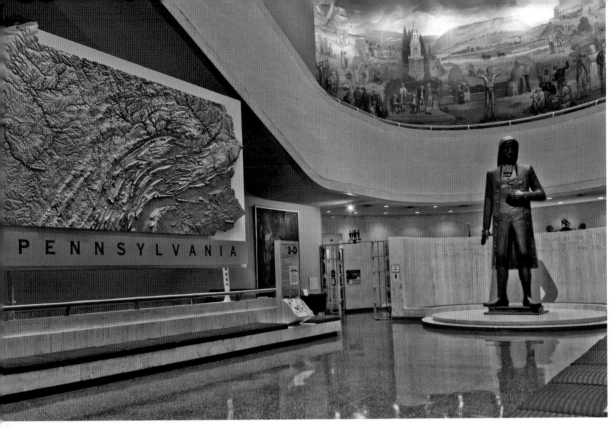

Visitors to the State Museum of Pennsylvania in Harrisburg can explore the arts, culture, and the natural and human history of Pennsylvania through four floors of exhibits and displays.

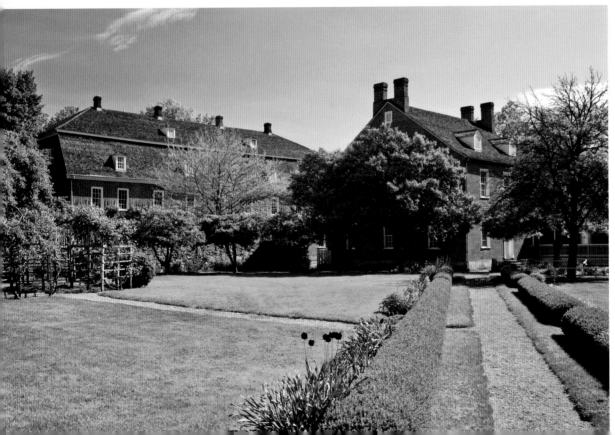

Old Economy Village, a National Historic Landmark in Beaver County, preserves and interprets the building, artifacts, and story of the Harmony Society, a nineteenth-century religious communal society. The Pennsylvania Historical & Museum Commission owns and operates the village and museum.

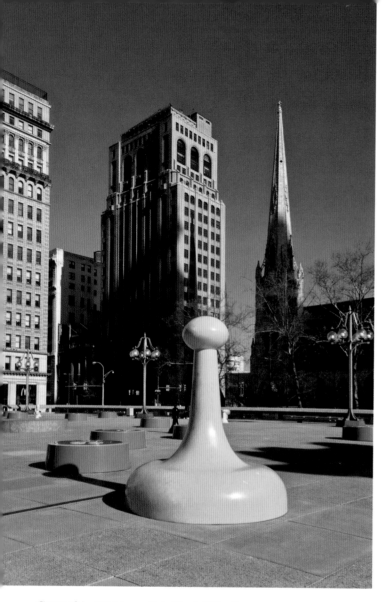

Created in 1996 by artists Daniel Martinez, Renee Petropoulis, and Roger White, the *Your Move* sculpture at Philadelphia's Municipal Services Building Plaza features twelve- to eighteen-foot-high board game pieces from Monopoly, bingo, chess, and dominoes.

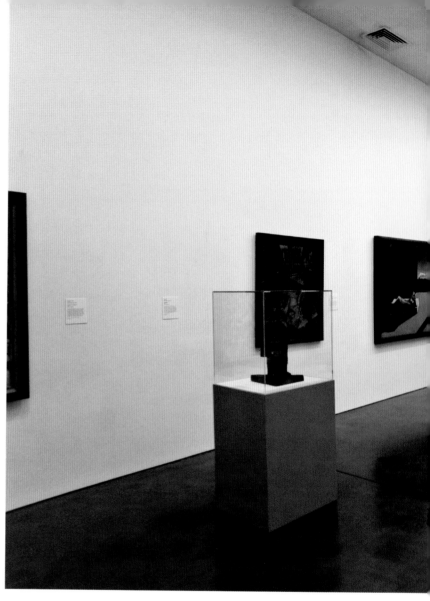

The Philadelphia Museum of Art, established in 1876, is one of the largest art museums in the US. It contains over 227,000 American and European paintings, sculptures, photographs, antiquity, and decorative arts.

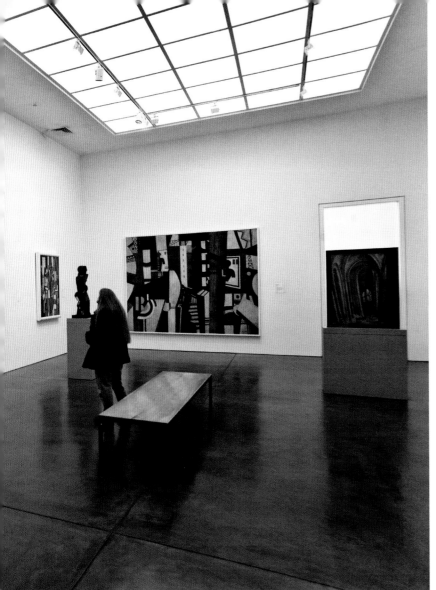

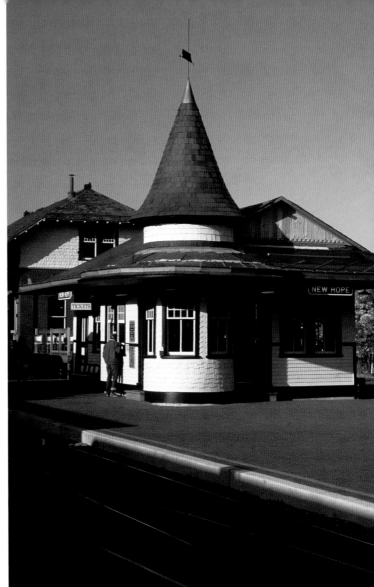

The Victorian design New Hope Railroad Station in Bucks County, serves the short line and passenger excursion Reading and New Hope Railroad.

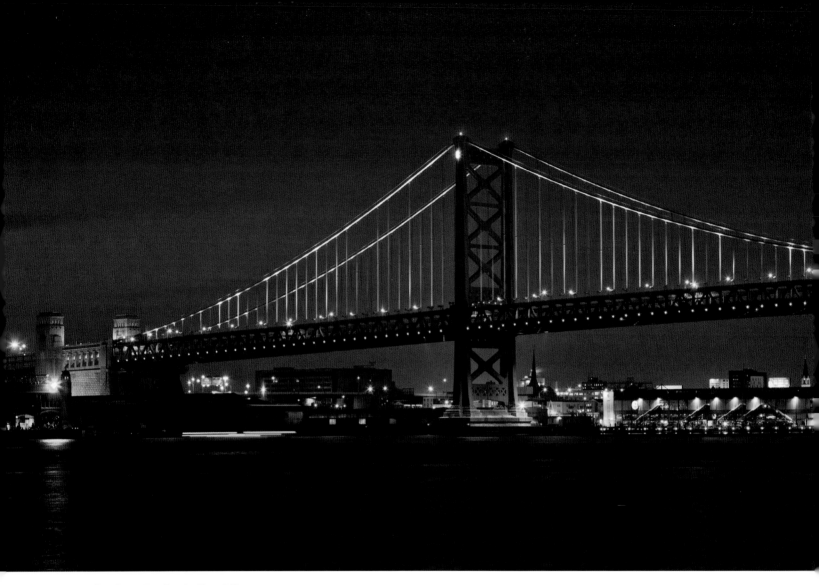

The 9,573-foot-long Benjamin Franklin
Bridge carries Interstate 676 traffic
across the Delaware River from
Philadelphia to Camden, New Jersey. It
was dedicated in 1926 as part of the
Sesquicentennial Exposition celebrating
the 150th anniversary of the signing of
the Declaration of Independence.

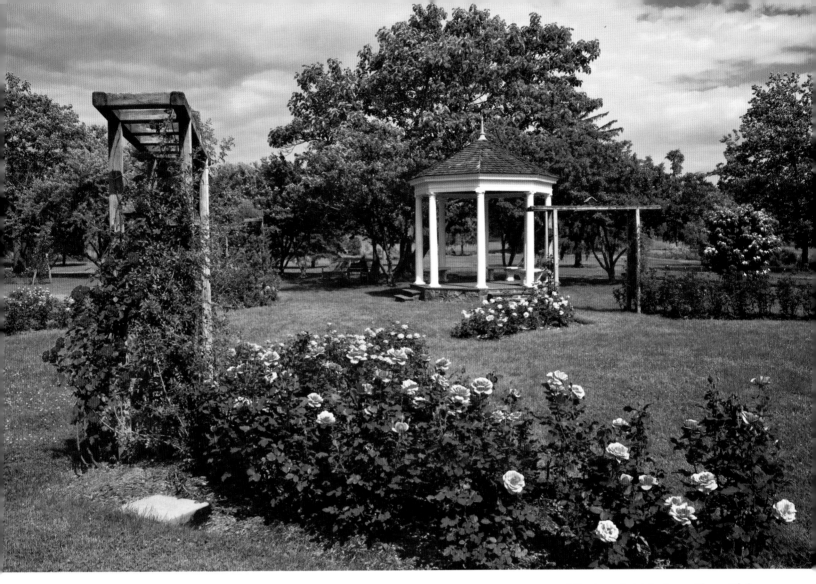

Allentown's historic and beautiful
Malcolm W. Gross Rose Garden,
managed by the city's Department of
Parks & Recreation, is the scene of
many weddings when the roses are in
full bloom.

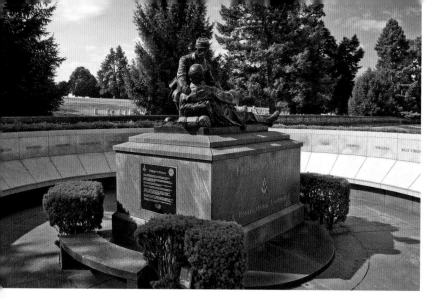

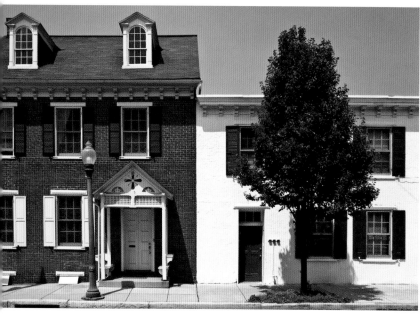

The Friend to Friend Masonic Memorial at Gettysburg National Military Parks honors the "Armistead-Bingham incident" when Union Captain Henry H. Bingham gave assistance to mortally wounded Confederate General Lewis A. Armistead. They fought on opposite sides during the war, but were both Freemasons.

The town of Lititz, in Lancaster County, contains many historic log, brick, and stone homes with a mixture of German, English, and Victorian influences. It was first settled in 1720 by Pennsylvania Germans.

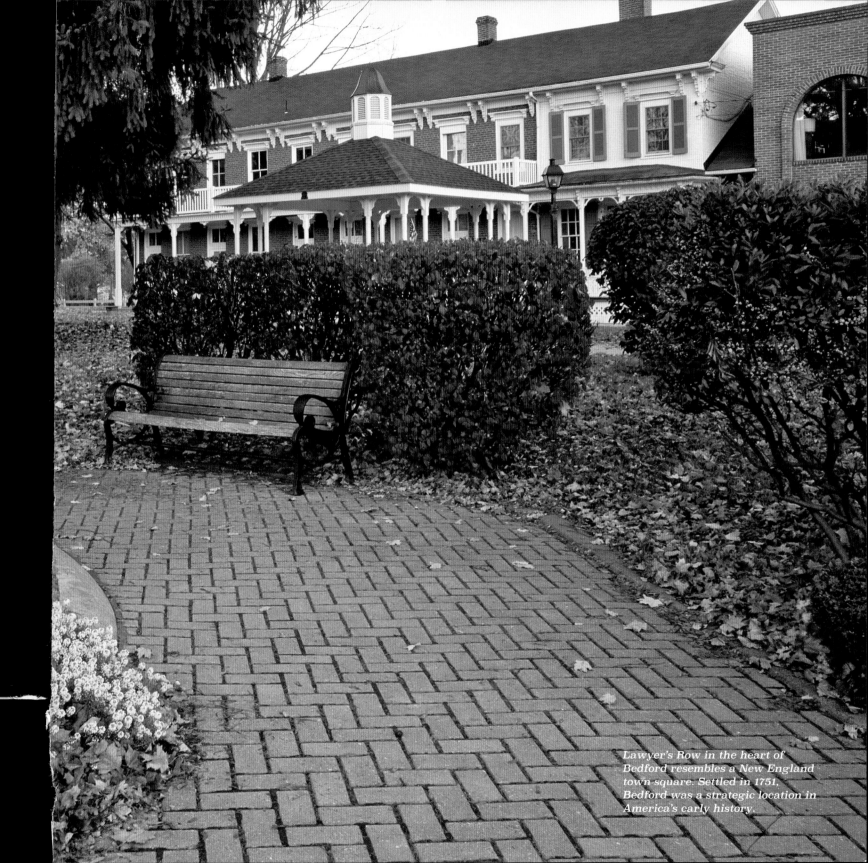

Lawyer's Row in the heart of
Bedford resembles a New England
town square. Settled in 1751,
Bedford was a strategic location in
America's early history.

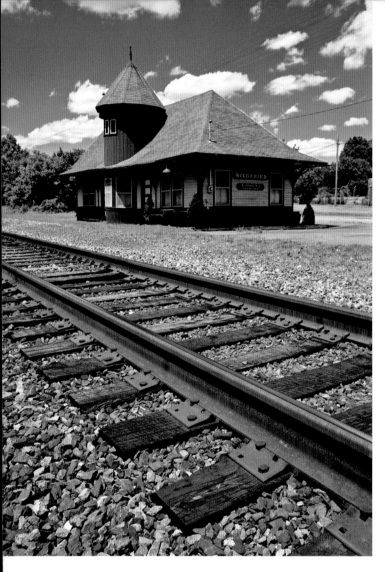

The Victorian-era Siegfried rail station in Northampton Borough, Northampton County, served the Central Railroad of New Jersey until passenger service was discontinued in 1945. The building was restored in 1976 and now houses the Northampton Area Historical Society.

Once a bustling lumber and leather-tanning center, scenic Galeton, along the Pine Creek in Potter County, now supports light industry and tourism. Potter County bills itself "Pennsylvania's God Country."

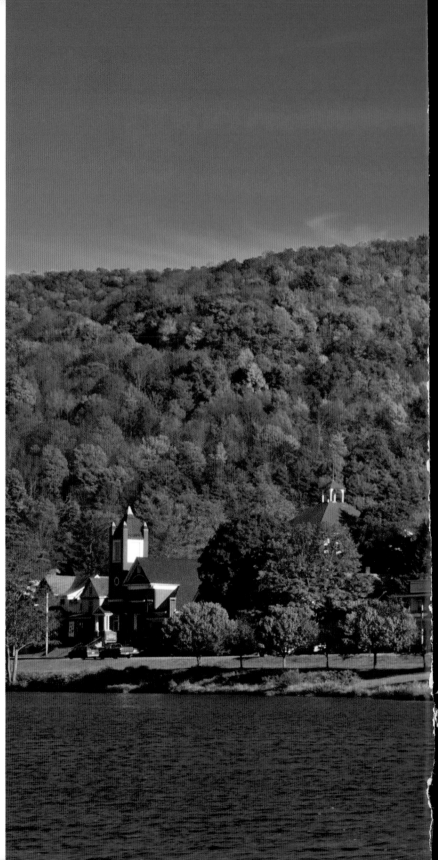

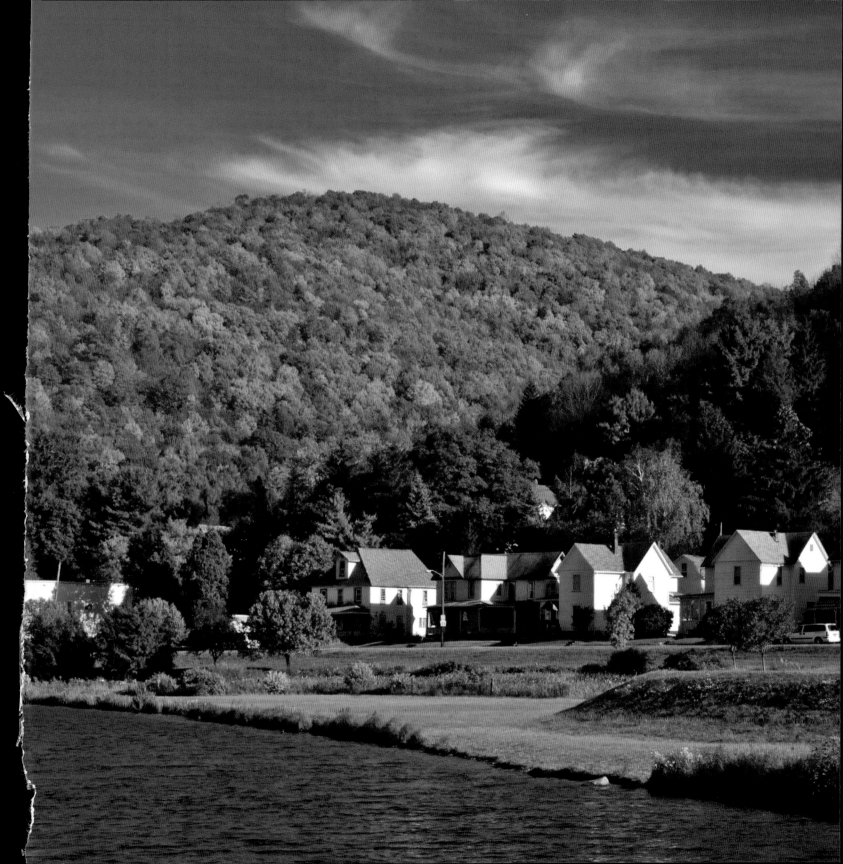

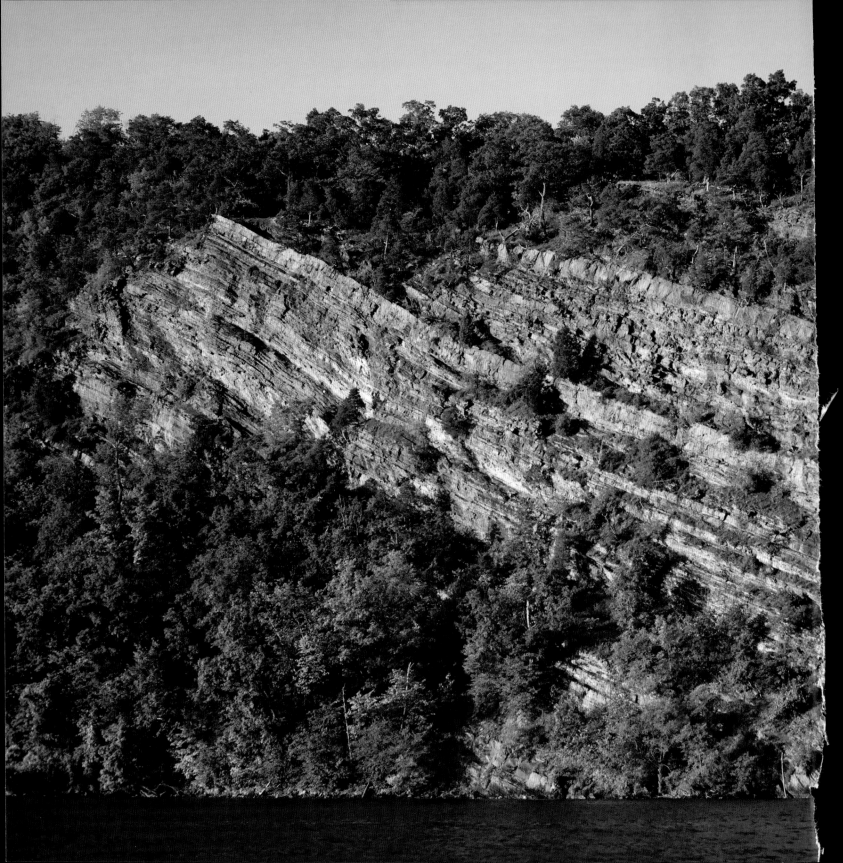

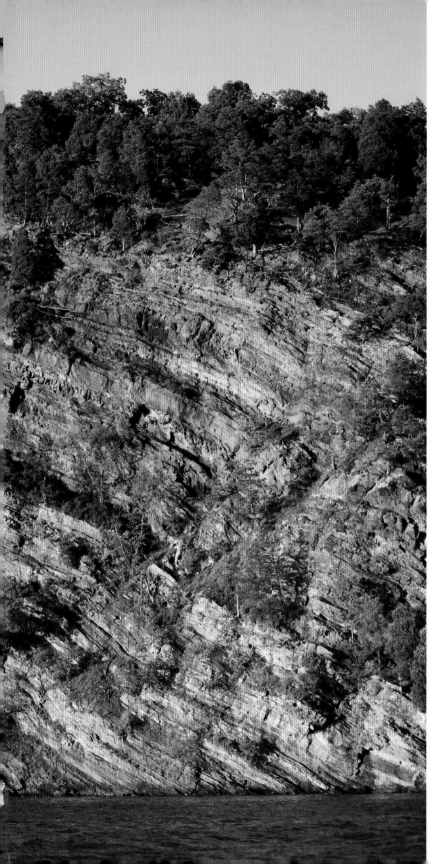

The fragile shale cliffs at Raystown Lake in Huntingdon County harbor bonsai-like trees such as red cedar and rare plants such as prickly-pear cactus.

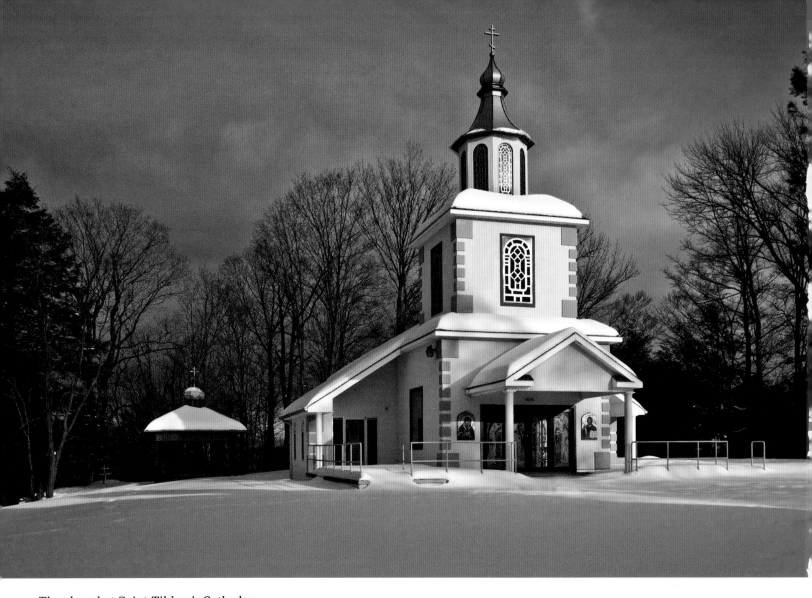

*The chapel at Saint Tikhon's Orthodox
Monastery and Theological Seminary
rests solemnly on a winter's day in Wayne
County. Established in 1905, St. Tikhon's
is the oldest Russian Orthodox monastery
in America.*